THE ILLUSTRATED
SCREENPLAY

PUBLISHED BY DEL REY BOOKS:

Art of Star Wars: A New Hope

Art of Star Wars: The Empire Strikes Back

Art of Star Wars: Return of the Jedi

Star Wars: A New Hope
The National Public Radio Dramatization

Star Wars: The Empire Strikes Back
The National Public Radio Dramatization

Star Wars: Return of the Jedi
The National Public Radio Dramatization

Star Wars: The Annotated Screenplays

A Guide to the Star Wars Universe

Star Wars Encyclopedia

Star Wars: A New Hope
The Illustrated Screenplay

Star Wars: The Empire Strikes Back
The Illustrated Screenplay

Star Wars: Return of the Jedi
The Illustrated Screenplay

THE ILLUSTRATED
SCREENPLAY

LEIGH BRACKETT
AND
LAWRENCE KASDAN

THE BALLANTINE PUBLISHING GROUP
NEW YORK

A Del Rey® Book
Published by The Ballantine Publishing Group

All rights reserved under International and Pan-American Copyright Conventions.
Published in the United States by The Ballantine Publishing Group, a division of
Random House, Inc., New York, and simultaneously in Canada by Random House
of Canada Limited, Toronto. Originally published in different form as *Star Wars:
The Art of the Empire Strikes Back* in 1997.

http://www.randomhouse.com/delrey/

Library of Congress Catalog Card Number: 97-97055

ISBN: 0-345-42070-5

Manufactured in the United States of America

First Edition: April 1998

10 9 8 7 6 5 4 3 2 1

INTRODUCTION

by Irvin Kershner

When I was about eleven years old I designed a rocket ship. In my mind it was a highly original design (by way of the Buck Rogers Saturday afternoon cinema). I hid the elaborate plans from spying enemy eyes, for by that time I had learned through my movie experience that the enemy was ever present. One problem remained to be solved: the propulsion system. I saved my pennies, worked after school selling apple-taffies, and finally purchased a chemical set.

Our kitchen became a laboratory when no one was home. I mixed solutions, boiled nasty-smelling liquids, and finally reached my goal . . . a full blown explosion, which fortunately occurred when I was out of the room. The miraculous transformation of the kitchen decor insured an end to the experiment.

Many years later I faced a full scale "rocket ship" which I had to make fly. The experience of my primitive chemical set would be of no help but the dream that sustained it would provide all the psychic energy I needed to make it soar into hyperspace. The propulsion problem was solved by going back to the source of my dream—the movies. I believed the dream as I struggled each day to make the many illusions reflect the truth of a world that never existed, but was made to live through the conventionalized reality that is cinema.

For years many people have told me that after seeing *Empire* they tried to make objects move by concentration and willpower. If Luke could do it maybe they also had some of that "Force." Not such a far out notion. When I was a child, long before *Empire* or *Star Wars*, I often tried to make objects move

v

with my enormous reservoir of concentrated psychic powers. Perhaps on the road to understanding and harnessing the power of mind over matter, we are experiencing cinema as reality. In the movies seeing is believing. Can we assume that cinema is any more or less an illusion than life itself? Cinema is always an experience in the present. But see a film again and again and it changes. What we see is our own dream. We get what we give and as we get older and have more experience in living (and sometimes getting wiser) we respond to the film from a changing perspective and altered perception. First we may see it as a child, then as a know-it-all adolescent, and later as a parent. Our response is defined by who we are and where we are in time. The film remains the same; we change. Perhaps some of the power of the *Star Wars* trilogy lies in its ambiguity. This offers a gateway to interpretation, an open-ended journey that is unique for each one of us.

The power of cinema is that it is fantasy that mirrors an inner life. A film sends many messages—political, psychological, spiritual—no matter how simple-minded the story may be.

In *Empire* we've created a world that doesn't exist, has never existed, and will never exist. It is a time and place entirely made up . . . a huge incredible lie, but like a parallel universe it reflects the truth. Fable, myth, fairy tales, legends all finally come together and are externalized by cinema and enter our unconscious from where they were originally born.

What a miracle the movies are. As an audience we can love, hate, rob, kill, be heroic, risk death, make choices that in real life would be cowardly to choose and all this done in the complete safety of vicarious experience. Books, theater, and story telling did the job well but how more hypnotic and effective to sit in a darkened room, safely surrounded by fellow humans, and see the dream made manifest. The cinema breaks down our internal censors and permits us to experience the most

antisocial as well as the most heroic behavior. With repetition it has the residual effect of changing our perception of the world.

Just as this film affects an audience it also affected me in the making of it. Working for years on an imaginative project like *The Empire Strikes Back* I had to believe in the universe being created. Without this strong belief, the lie of re creation would never become the truth of creation.

At the heart of *Empire* is a secret, the nucleus that generates the energy that drives the film. Fathers and sons have forever provided strong themes for stories and myths. In this fairy tale there is a secret bond between two antagonists, who are father and son. The son needs to find himself, his power, his independence. The father needs his son's power to maintain his own.

Finally the inevitable battle in which the father emasculates the son by cutting off his hand, an image that is a shock to the audience and that reverberates deeply into their unconscious. Luke and Darth Vader never existed in real life but they have become as real as any memory.

The son must make a difficult choice, to accept this evil father, gain great power, and give up his independence, or to risk death. Young people must finally face their own fears and either conquer them or avoid confrontation and be haunted forever. Luke chooses not to compromise and makes the choice that catapults him through extreme danger to independence and insight.

I have been asked to what I attribute the long life of the trilogy. When we visit a foreign country we are bombarded with visual stimuli that we perceive on a quite superficial level. *Empire* on first viewing is like visiting a foreign world. We see and hear what moves the story forward. The peripheral world, the story in depth, the psychological overtones of this foreign culture still lies partially submerged. On second and third viewing the story is more familiar and that which was ambiguous

now begins to surface and reveal hitherto hidden levels of meaning as they bypass the conscious mind and we are thrust deeper into our own reservoir of experience and emotions, our subconscious.

The initial conception of the trilogy by George Lucas is what makes it all possible. He had a vision that opened the door to a universe of possibilities. All I had to do was explore, interpret, find the dramatic moments, and keep it from becoming pretentious and above all from being boring.

It is about eighteen years since the release of *The Empire Strikes Back*. In rereading the screenplay I feel a gnawing anxiety. The words haven't changed but my life has. I wonder how I would interpret the script today. What scenes I would redo or cut. No film is ever complete. Compromises were made when we decided the script was ready, when I did the preproduction, when I filmed in Norway and England, and when I edited the footage. These compromised moments pop into consciousness when reading the script or when viewing the film. Wouldn't it be nice to fix this or that, to reevaluate, to recut, or possibly to just rescript and reshoot the whole damn thing.

Maybe that is the power of film, a living fantasy, frozen in time but always in the present. It keeps changing its message as we grow older and sometimes wiser. What remains is not mechanics but an inner voice, a dream.

—Irvin Kershner

A long time ago in a galaxy far, far away . . .

It is a dark time for the Rebellion. Although the Death Star has been destroyed, Imperial troops have driven the Rebel forces from their hidden base and pursued them across the galaxy.

Evading the dreaded Imperial Starfleet, a group of freedom fighters led by Luke Skywalker has established a new secret base on the remote ice world of Hoth.

The evil lord Darth Vader, obsessed with finding young Skywalker, has dispatched thousands of remote probes into the far reaches of space . . .

EXTERIOR: GALAXY—PLANET HOTH

A Star Destroyer moves through space, releasing Imperial probe robots from its underside.

One of these probes zooms toward the planet Hoth and lands on its ice-covered surface. An explosion marks the point of impact.

EXTERIOR: HOTH—METEORITE CRATER—SNOW PLAIN—DAY

A weird mechanical sound rises above the whining of the wind. A strange probe robot, with several extended sensors, emerges from the smoke-shrouded crater. The ominous mechanical probe floats across the snow plain and disappears into the distance.

EXTERIOR: PLAIN OF HOTH—DAY

A small figure gallops across the windswept ice slope. The bundled rider is mounted on a large gray snow lizard, a tauntaun. Curving plumes of snow rise from beneath the speeding paws of the two-legged beast.

The rider gallops up a slope and reins his lizard to a stop. Pulling off his protective goggles, Luke Skywalker notices something in the sky. He takes a pair of electrobinoculars from his utility belt and through them sees smoke rising from where the probe robot has crashed.

The wind whips at Luke's fur-lined cap and he activates a comlink transmitter. His tauntaun shifts and moans nervously beneath him.

LUKE: *(into comlink)* Echo Three to Echo Seven. Han, old buddy, do you read me?

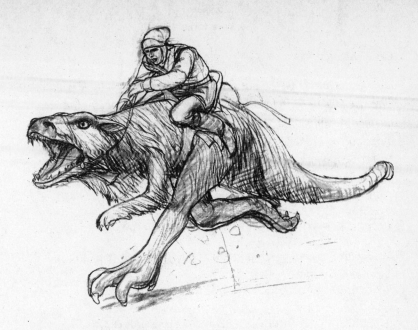

After a little static a familiar voice is heard.

HAN: *(over comlink)* Loud and clear, kid. What's up?

LUKE: *(into comlink)* Well, I finished my circle. I don't pick up any life readings.

HAN: *(over comlink)* There isn't enough life on this ice cube to fill a space cruiser. The sensors are placed. I'm going back.

LUKE: *(into comlink)* Right. I'll see you shortly. There's a meteorite that hit the ground near here. I want to check it out. It won't take long.

Luke clicks off his transmitter and reins back on his nervous lizard. He pats the beast on the head to calm it.

LUKE: Hey, steady girl. What's the matter? You smell something?

Luke takes a small device from his belt and starts to adjust it when suddenly a large shadow falls over him from behind. He hears a monstrous howl and turns to see an eleven-foot-tall shape towering over him. It is a wampa ice creature, lunging at him ferociously.

LUKE: Aaargh!

Luke grabs for his pistol, but is hit flat in the face by a huge white claw. He falls unconscious into the snow and in a moment the terrified screams of the tauntaun are cut short by the horrible snap of a neck being broken.

The wampa ice creature grabs Luke by one ankle and drags him away across the frozen plain.

EXTERIOR: HOTH—REBEL BASE ENTRANCE—DAY

A stalwart figure rides his tauntaun up to the entrance of an enormous ice cave.

INTERIOR: HOTH—REBEL BASE—MAIN HANGAR DECK

Rebel troopers rush about unloading supplies and otherwise securing their new base. The rider, Han Solo, swings off his lizard and pulls off his goggles.

He walks into the main hangar deck toward the Millennium Falcon, *which is parked among several fighters. Mechanics, R2 units, and various other droids hurry about. Han stops at the* Millennium Falcon *where his Wookiee copilot, Chewbacca, is welding on a central lifter. Chewie stops his work and lifts his face shield, growling an irritated greeting to his boss.*

HAN: Chewie!

The Wookiee grumbles a reply.

HAN: All right, don't lose your temper. I'll come right back and give you a hand.

Chewbacca puts his mask back on and returns to his welding as Han leaves.

INTERIOR: HOTH—REBEL BASE—COMMAND CENTER

A makeshift command center has been set up in a blasted area of thick ice. The low-ceilinged room is a beehive of activity. Controllers, troopers, and droids move about setting up electronic equipment and monitoring radar signals.

General Rieekan straightens up from a console at Han's approach.

RIEEKAN: Solo?

HAN: No sign of life out there, General. The sensors are in place. You'll know if anything comes around.

RIEEKAN: Commander Skywalker reported in yet?

HAN: No. He's checking out a meteorite that hit near him.

RIEEKAN: *(indicates radar screen)* With all the meteor activity in this system, it's going to be difficult to spot approaching ships.

Taking a deep breath, Han blurts out what is on his mind.

HAN: General, I've got to leave. I can't stay anymore.

Princess Leia, standing at a console nearby, is dressed in a short white combat jacket and pants. Her hair is braided and tied across her head in a Nordic fashion. She overhears their conversation and seems somewhat distressed.

RIEEKAN: I'm sorry to hear that.

HAN: Well, there's a price on my head. If I don't pay off Jabba the Hutt, I'm a dead man.

RIEEKAN: A death mark's not an easy thing to live with. You're a good fighter, Solo. I hate to lose you.

HAN: Thank you, General.

He turns to Leia as Rieekan moves away.

HAN: *(with feeling)* Well, Your Highness, I guess this is it.

LEIA: That's right.

Leia is angry. Han sees she has no warmth to offer him. He shakes his head and adopts a sarcastic tone.

HAN: *(coolly)* Well, don't get all mushy on me. So long, Princess.

Han walks away into the quiet corridor adjoining the command center. Leia stews a moment, then hurries after him.

INTERIOR: HOTH—REBEL BASE—ICE CORRIDOR

LEIA: Han!

Han stops in the corridor and turns to face Leia.

HAN: Yes, Your Highnessness?

LEIA: I thought you had decided to stay.

HAN: Well, the bounty hunter we ran into on Ord Mantell changed my mind.

LEIA: Han, we need you!

HAN: We?

LEIA: Yes.

HAN: Oh, what about *you* need?

LEIA: *(mystified)* I need? I don't know what you're talking about.

HAN: *(shakes his head, fed up)* You probably don't.

LEIA: And what precisely am I supposed to know?

HAN: Come on! You want me to stay because of the way you feel about me.

LEIA: Yes. You're a great help to us. You're a natural leader . . .

HAN: No! That's not it. Come on. Aahhh—uh-huh! Come on.

Leia stares at him, understands, then laughs.

LEIA: You're imagining things.

HAN: Am I? Then why are you following me? Afraid I was going to leave without giving you a good-bye kiss?

LEIA: I'd just as soon kiss a Wookiee.

HAN: I can arrange that. You could use a good kiss!

Angrily, Han strides down the corridor as Leia stares after him.

INTERIOR: HOTH—REBEL BASE—ANOTHER ICE CORRIDOR

A familiar stream of beeps and whistles heralds the approach of Artoo-Detoo and See-Threepio, who appear around a corner and move along an ice wall toward the main hangar.

THREEPIO: Don't try to blame me. I didn't ask you to turn on the thermal heater. I merely commented that it was freezing in the princess's chamber. But it's *supposed* to be freezing. How are we going to dry out all her clothes? I really don't know.

Artoo beeps a stream of protesting whistles.

THREEPIO: Oh, switch off.

INTERIOR: HOTH—REBEL BASE—MAIN HANGAR DECK

The two robots stop at Han Solo's space freighter. Han and Chewie are still struggling with their central lifters.

HAN: *(to Chewie)* Why do you take this apart now? I'm trying to get us out of here and you pull both of these.

Chewie grumbles in irritation.

THREEPIO: Excuse me, sir.

HAN: *(to Chewie)* Put them back together right now.

THREEPIO: Might I have a word with you, please?

HAN: What do you want?

THREEPIO: Well, it's Princess Leia, sir. She's been trying to get you on the communicator.

HAN: I turned it off. I don't want to talk to her.

THREEPIO: Oh. Well, Princess Leia is wondering about Master Luke. He hasn't come back yet. She doesn't know where he is.

HAN: *I* don't know where he is.

THREEPIO: Nobody knows where he is.

HAN: What do you mean, "nobody knows"?

Han glances at the fading light at the entrance of the ice cave as night slowly begins to fall on the planet.

THREEPIO: Well, uh, you see . . .

Han jumps down off the lift, as Threepio follows him.

HAN: Deck Officer. Deck Officer!

THREEPIO: Excuse me, sir. Might I inqu-. . .

Han abruptly puts his hand over Threepio's mouth as the deck officer approaches.

DECK OFFICER: Yes, sir?

HAN: Do you know where Commander Skywalker is?

DECK OFFICER: I haven't seen him. It's possible he came in through the south entrance.

HAN: It's possible? Why don't you go find out? It's getting dark out there.

DECK OFFICER: Yes, sir.

The deck officer leaves hurriedly, as Han takes his hand off Threepio's mouth.

THREEPIO: Excuse me, sir. Might I inquire what's going on?

HAN: Why not?

THREEPIO: Impossible man. Come along, Artoo, let's find Princess Leia. Between ourselves, I think Master Luke is in considerable danger.

INTERIOR: HOTH—REBEL BASE—MAIN ICE TUNNEL

The deck officer and his assistant hurry toward Han as he enters the tunnel.

DECK OFFICER: Sir, Commander Skywalker hasn't come in through the south entrance. He might have forgotten to check in.

HAN: Not likely. Are the speeders ready?

DECK OFFICER: Not yet. We're having some trouble adapting them to the cold.

HAN: Then we'll have to go out on tauntauns.

DECK OFFICER: Sir, the temperature's dropping too rapidly.

HAN: That's right. And my friend's out in it.

ASSISTANT OFFICER: I'll cover sector twelve. Have com-control set screen alpha.

Han pushes through the troops and mounts a tauntaun.

9

DECK OFFICER: Your tauntaun'll freeze before you reach the first marker.

HAN: Then I'll see you in hell!

Han maneuvers his mount out of the cave and races into the dark and bitter night.

EXTERIOR: HOTH—ICE GORGE—DUSK

The jagged face of a huge ice wall sits gloomily in the dim twilight of a Hoth day. Luke hangs upside down, ankles frozen into icy stalactites, his extended arms within a foot of the snow floor. One side of his face is covered in a dried mask of frozen blood. He opens his eyes as a chilling moan of the hideous ice creature echoes off the gorge walls. Luke pulls himself up, grabs hold of his ankles, and futilely tries to unfasten the thongs.

Exhausted, he drops back into his hanging position. As he hangs there, he spies his lightsaber lying near a pile of his discarded gear, about three feet out of reach.

He focuses on the saber and, as his hand strains toward the weapon, he squeezes his eyes tight in concentration.

Just as the ice creature looms over Luke, the lightsaber jumps into Luke's hand.

The young warrior instantly ignites his sword, swings up, and cuts himself loose from the ice. He flops to the snow in a heap. The startled creature moves back, his giant yellow eyes blinking. Luke scrambles to his feet. He swings his lightsaber and the beast screams in pain.

EXTERIOR: HOTH—ENTRANCE TO ICE GORGE—DUSK

Luke staggers out of the gorge into the dark and snowy twilight. Weak and exhausted, he stumbles down a snow bank.

EXTERIOR: HOTH—SNOW PLAIN—DUSK

A small, lone figure riding a tauntaun races through the hostile vastness of snow and cold. As it runs, the tauntaun's legs kick up large clouds of snow and ice into the snowy air.

EXTERIOR: HOTH—OUTSIDE ICE HANGAR—DUSK

Artoo stands in the falling snow, beeping worriedly. Threepio moves stiffly over to him.

THREEPIO: You must come along now, Artoo. There's really nothing more we can do. And my joints are freezing up.

Artoo beeps, long and low.

THREEPIO: Don't say things like that! Of course we'll see Master Luke again. He'll be quite all right, you'll see. *(to himself)* Stupid little short-circuit. He'll be quite all right.

Threepio turns to go back inside the main hangar as Artoo mournfully keeps his vigil.

EXTERIOR: HOTH—SNOW DRIFT—DUSK

The wind is blowing quite strong now. Luke struggles to stay upright, but a blast of freezing snow knocks him over. He struggles to get up, but he can't. The young warrior from Tatooine drags himself a couple of feet and then collapses.

INTERIOR: REBEL BASE—MAIN HANGAR DECK—ENTRANCE—NIGHT

Princess Leia stands inside the dark entrance to the Rebel base, waiting for a sign of the two Rebel heroes. She shivers in the cold wind as, nearby, Chewie sits with his head in his hands. In the background, Artoo and Threepio move through the doors.

A Rebel lieutenant moves to Major Derlin, an officer keeping watch with the princess.

LIEUTENANT: Sir, all the patrols are in. There's still no contact from Skywalker or Solo.

THREEPIO: Mistress Leia, Artoo says he's been quite unable to pick up any signals, although he does admit that his own range is far too weak to abandon all hope.

Leia nods an acknowledgment, but she is lost in thought.

DERLIN: Your Highness, there's nothing more we can do tonight. The shield doors must be closed.

He turns to the lieutenant.

DERLIN: Close the doors.

LIEUTENANT: Yes, sir.

The lieutenant walks away. Chewie lets out a long, mournful howl, somewhat like a coyote. At the same moment, Artoo begins a complex series of efficient beeps.

THREEPIO: Artoo says the chances of survival are seven hundred seventy-five . . . to one.

Leia stands praying to herself as the huge metal doors slam across the entrances of the ice cave. The loud booms echo throughout the huge cavern. Chewie lets out another suffering howl.

THREEPIO: Actually, Artoo has been known to make mistakes . . . from time to time. Oh, dear, oh, dear. Don't worry about Master Luke. I'm sure he'll be all right. He's quite clever, you know . . . for a human being.

EXTERIOR: HOTH—SNOW DRIFT—DUSK

Luke lies face down in the snow, nearly unconscious. Slowly he looks up and sees Ben Kenobi, barely visible through the blowing snow. It is hard to tell if Kenobi is real or a hallucination.

BEN: Luke . . . Luke.

LUKE: *(weakly)* Ben?

BEN: You will go to the Dagobah system.

LUKE: Dagobah system?

BEN: There you will learn from Yoda, the Jedi Master who instructed me.

The image of Ben fades, revealing a lone tauntaun rider approaching from the windswept horizon.

LUKE: *(groaning faintly)* Ben . . . Ben.

Luke drops into unconsciousness.
 Han pulls up and leaps off his mount. He hurries to his snow-covered friend, cradling him in his arms. Han's tauntaun lets out a low, pitiful bellow. But Han's concern is with Luke, and he shakes him urgently.

HAN: Luke! Luke! Don't do this, Luke. Come on, give me a sign here.

Luke doesn't respond. Han begins frantically rubbing and slapping Luke's unconscious face. As he starts to lift the youth, Han hears a rasping sound behind him. He turns, just in time to see his tauntaun stagger and then fall over into the snow.
 Han carries Luke to the moaning beast. Then, with a final groan, the tauntaun expires.

HAN: Not much time.

He pushes Luke's inert form against the belly of the dead beast.

LUKE: *(moaning)* Ben . . . Ben . . .

HAN: Hang on, kid.

LUKE: Dagobah system . . .

Han ignites Luke's saber and cuts the beast from head to toe. He quickly tosses its steaming innards into the snow, then lifts Luke's inert form and stuffs him inside the carcass.

HAN: *(reeling from the odor)* Whew . . .

LUKE: Dagobah . . .

HAN: This may smell bad, kid . . .

LUKE: *(moaning)* Yoda . . .

HAN: . . . but it will keep you warm . . . till I get the shelter built. *(struggling to get Luke inside the carcass)* Ooh . . . I thought they smelled bad on the outside!

The wind has picked up considerably, making it difficult to move. Han removes a pack from the dead creature's back, taking out a shelter container. He begins to set up what can only be a pitiful protection against a bitter Hoth night.

EXTERIOR: HOTH—SNOWDRIFT—DAWN

Four snub-nosed armored snowspeeders race across the white landscape.

INTERIOR: SNOWSPEEDER—COCKPIT

There is only one pilot, Zev, in the enclosed two-man craft. He concentrates on the scopes which ring his cockpit. He hears a low beep from one of his monitors.

ZEV: *(into transmitter)* Echo Base . . . I've got something! Not much, but it could be a life form.

EXTERIOR: HOTH—SNOWDRIFT

The small craft banks and makes a slow arc, then races off in a new direction.

INTERIOR: SNOWSPEEDER—COCKPIT

The pilot switches over to a new transmitter.

ZEV: *(into transmitter)* This is Rogue Two. This is Rogue Two. Captain Solo, do you copy? Commander Skywalker, do you copy? This is Rogue Two.

There is a sharp crackle of static, then a faint voice.

HAN: *(filtered over Zev's receiver)* Good morning. Nice of you guys to drop by.

ZEV: *(switching transmitters)* Echo Base . . . this is Rogue Two. I found them. Repeat, I found them.

EXTERIOR: HOTH—SNOWDRIFT—DAY

The small shelter Han has set up is covered with snow on the windward side. A makeshift antenna rests gingerly on top of the snowdrift. Han spots Zev's snowspeeder approaching in the distance, and begins waving frantically at the tiny craft.

INTERIOR: REBEL BASE—MEDICAL CENTER

Strange robot surgeons adjust a mass of electronic equipment. A switch is thrown and a sudden blinding flash obscures Luke in a bacta tank filled with a thick, gelatinous slime. He begins to thrash about, raving in his delirium.

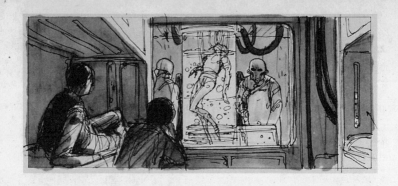

INTERIOR: REBEL BASE—MEDICAL CENTER—RECOVERY ROOM

Luke sits up in a recovery-room bed, weak but smiling. His face shows terrible wounds from the wampa's attack. Threepio and Artoo enter the room.

THREEPIO: *Master Luke, sir, it's so good to see you fully functional again.*

Artoo beeps his good wishes.

THREEPIO: Artoo expresses his relief, also.

Han and Chewie make their entrance. The Wookiee growls a greeting.

HAN: How are you feeling, kid? You don't look so bad to me. In fact, you look strong enough to pull the ears off a gundark.

LUKE: Thanks to you.

HAN: That's two you owe me, junior.

Han turns as Leia enters the room. He looks at her with a big, devilish grin.

HAN: Well, Your Worship, looks like you managed to keep me around for a little while longer.

LEIA: *(haughtily)* I had nothing to do with it. General Rieekan thinks it's dangerous for any ships to leave the system until we've activated the energy shield.

HAN: That's a good story. *I* think you just can't bear to let a gorgeous guy like me out of your sight.

LEIA: I don't know where you get your delusions, laser brain.

Chewie is amused; he laughs in his manner. Han, enjoying himself, regards Chewie good-humoredly.

HAN: Laugh it up, fuzzball. But you didn't see us alone in the south passage.

Luke sparks to this; he looks at Leia.

HAN: She expressed her true feelings for me.

Leia is flushed, eyes darting between Luke and Han.

LEIA: My ...! Why, you stuck-up, ... half-witted, ... scruffy-looking ... nerf-herder!

HAN: Who's scruffy-looking? *(to Luke)* I must have hit pretty close to the mark to get her all riled up like that, huh, kid?

Leia looks vulnerable for a moment, then the mask falls again, and she focuses on Luke.

LEIA: Why, I guess you don't know everything about women yet.

With that she leans over and kisses Luke on the lips. Then she turns on her heel and walks out, leaving everyone in the room slightly dumbstruck. With some smugness, Luke puts his hands behind his head and grins.

Suddenly, in the distance, the muffled sound of an alarm is heard.

ANNOUNCER: *(over loudspeaker)* Headquarters personnel, report to command center.

The voice repeats the order and Han, Chewie, Artoo, and Threepio hurry out of the room, bidding farewell to Luke.

HAN: Take it easy.

THREEPIO: Excuse us, please.

INTERIOR: HOTH—REBEL BASE—COMMAND CENTER

Rieekan looks up grimly from a console screen. He calls over to Leia and Han.

RIEEKAN: Princess . . . we have a visitor.

The group hurries over to Rieekan.

RIEEKAN: We've picked up something outside the base in zone twelve, moving east.

SENIOR CONTROLLER: It's metal.

LEIA: Then it couldn't be one of those creatures that attacked Luke.

HAN: It could be a speeder, one of ours.

SENIOR CONTROLLER: No. Wait—there's something very weak coming through.

Threepio steps up to the control panel and listens intently to the strange signal.

THREEPIO: Sir, I am fluent in six million forms of communication. This signal is not used by the Alliance. It could be an Imperial code.

The transmission ends in static.

HAN: It isn't friendly, whatever it is. Come on, Chewie, let's check it out.

RIEEKAN: Send Rogues Ten and Eleven to station three-eight.

EXTERIOR: HOTH—SNOW PLAIN—DAY

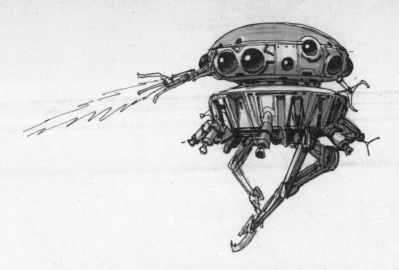

The dark probe robot moves past the smoldering ruins of station three-eight and down a ridge toward the Rebel base. It raises a large antenna from the top of its head and begins to send out a piercing signal.

The probe droid has spotted Chewbacca who, not thirty feet away, has popped his head over a snow bank. Instantly, the probe robot swings around, its deadly ray ready to fire. But before it can get a shot off, it is hit from behind by a laser bolt, and explodes in a million pieces.

Han Solo replaces his blaster in its holster and peers intently at the smoldering remains of the Imperial probe.

INTERIOR: HOTH—REBEL BASE—COMMAND CENTER

Leia and Rieekan listen to Han on the comlink.

HAN: (over comlink) Afraid there's not much left.

LEIA: (into comlink) What was it?

HAN: (over comlink) Droid of some kind. I didn't hit it that hard. It must have had a self-destruct.

LEIA: (into comlink) An Imperial probe droid.

HAN: *(over comlink)* It's a good bet the Empire knows we're here.

RIEEKAN: We'd better start the evacuation.

EXTERIOR: SPACE—IMPERIAL FLEET

Darth Vader's Star Destroyer, larger and more awesome than the five Imperial Star Destroyers that surround it, sits in the vastness of space. The six huge ships are surrounded by a convoy of smaller spacecraft. TIE fighters dart to and fro.

INTERIOR: DARTH VADER'S STAR DESTROYER—BRIDGE—MAIN CONTROL DECK

Controllers working the vast complex of electronic controls hear ominous approaching footsteps and look up from their controls. The squat, evil-looking Admiral Ozzel and the young, powerfully built General Veers, who have been conferring near the front, also feel the approaching presence and turn toward it. Darth Vader, Lord of the Sith, enters like a chill wind. As Vader moves across the wide bridge, Captain Piett hurries up to Ozzel.

PIETT: Admiral.

OZZEL: Yes, Captain?

PIETT: I think we've got something, sir. The report is only a fragment from a probe droid in the Hoth system, but it's the best lead we've had.

OZZEL: *(irritated)* We have thousands of probe droids searching the galaxy. I want proof, not leads!

PIETT: The visuals indicate life readings.

OZZEL: It could mean anything. If we followed up every lead . . .

PIETT: But, sir, the Hoth system is supposed to be devoid of human forms.

Vader moves to a large screen showing an image of the Rebel snow base. Rebel speeders can be seen approaching the base in the distance.

VADER: You found something?

PIETT: Yes, my lord.

VADER: *(studying the image on the console screen)* That's it. The Rebels are there.

OZZEL: My lord, there are so many uncharted settlements. It could be smugglers, it could be . . .

VADER: That is the system. And I'm sure Skywalker is with them. Set your course for the Hoth system. General Veers, prepare your men.

INTERIOR: HOTH—REBEL BASE—TRANSPORT BAY

A captain issues instructions to two of his men at the entrance to the main transport bay. Several Rebel transports behind them are being loaded by men carrying heavy boxes and moving quickly, but not in panic.

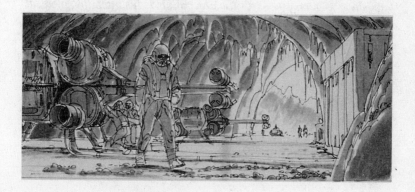

REBEL CAPTAIN: Groups seven and ten will stay behind to fly the speeders. As soon as each transport is loaded, evacuation control will give clearance for immediate launch.

REBEL FIGHTER: Right, sir.

INTERIOR: HOTH—REBEL BASE—MAIN HANGAR DECK

Alarms sound. Troops, ground crews, and droids rush to their alert stations. Armored snowspeeders are lined up in attack formation near the main entrance.

In the midst of all this activity, Han does some frantic welding on the lifters of the Millennium Falcon.

Han finishes his work and hops down to the hangar floor. He pulls out his comlink, all the while eyeing the problematic lifters.

HAN: *(into comlink, to Chewie)* Okay, that's it. Try it. . . . Off! Turn it off! Turn it off! Off!

Smoke rises from a minor explosion on the lifter. Exasperated, Han surveys the new damage.

INTERIOR: REBEL BASE—MEDICAL CENTER

Luke dresses in readiness for the evacuation as his attending medical droid stands by.

MEDICAL DROID: Sir, it will take quite a while to evacuate the T-forty-sevens.

LUKE: Well, forget the heavy equipment. There's plenty of time to get the smaller modules on the transports.

MEDICAL DROID: Take care, sir.

LUKE: Thanks.

INTERIOR: REBEL BASE—MAIN HANGAR DECK

Pilots, gunners, and R2 units scurry about. Luke, pulling on his heavy-weather jacket, is headed toward a row of armored speeders. He stops at the rear of the Millennium Falcon, *where Han and Chewie are trying to repair the right lifter with even more haste than before.*

LUKE: Chewie, take care of yourself, okay?

As Luke pats Chewie on the arm, Chewie puts his arms around Luke and gives him a tight hug. Han is discussing the lifter with a repair droid when he sees Luke.

HAN: Hi, kid. *(to droid)* There's got to be a reason for it. Check it at the other end. Wait a second. *(to Luke)* You all right?

LUKE: Yeah.

HAN: Be careful.

LUKE: You, too.

Luke smiles, then waves at his friend and walks on. After a few steps, he stops and looks back. Han glances up and the two exchange a silent communication, each wishing the other safety, happiness— many things, all difficult to verbalize.

INTERIOR: REBEL BASE—CONTROL ROOM

Alarms sound throughout the hidden Rebel base. In the control room, a controller urgently gestures for General Rieekan to check a computer scan.

CONTROLLER: General, there's a fleet of Star Destroyers coming out of hyperspace in sector four.

RIEEKAN: Reroute all power to the energy shield. We've got to hold them till all transports are away. Prepare for ground assault.

Rieekan exits hurriedly.

EXTERIOR: SPACE—IMPERIAL FLEET

Six huge Star Destroyers move through space into the Hoth system.

INTERIOR: VADER'S STAR DESTROYER—VADER'S CHAMBER—
MEDITATION CUBICLE

The dark cubicle is illuminated by a single shaft of light which falls on the brooding Dark Lord as he sits on a raised meditation cube. General Veers enters the room and approaches the silent, unmoving Vader. Although seemingly very sure of himself, Veers is still not bold enough to interrupt the meditating lord. The young general stands quietly at attention until the evil presence speaks.

VADER: What is it, General?

VEERS: My lord, the fleet has moved out of light-speed. Com-Scan has detected an energy field protecting an area around the sixth planet of the Hoth system. The field is strong enough to deflect any bombardment.

VADER: *(angrily)* The Rebels are alerted to our presence. Admiral Ozzel came out of light-speed too close to the system.

VEERS: He felt surprise was wiser . . .

VADER: He is as clumsy as he is stupid. General, prepare your troops for a surface attack.

VEERS: Yes, my lord.

Veers turns smartly and leaves as Vader activates a large viewscreen showing the bridge of his mighty ship. Admiral Ozzel appears on the viewscreen, standing slightly in front of Captain Piett.

OZZEL: Lord Vader, the fleet has moved out of light-speed, and we're preparing to . . . Aaagh!

VADER: You have failed me for the last time, Admiral. Captain Piett.

Piett steps forward, as the admiral moves away, slightly confused, touching his throat as it begins to constrict painfully.

PIETT: Yes, my lord.

VADER: Make ready to land our troops beyond the energy shield and deploy the fleet so that nothing gets off that system. You are in command now, *Admiral* Piett.

PIETT: Thank you, Lord Vader.

Piett's pleasure about his unexpected promotion is not an unmixed emotion. He glances warily at the struggling Admiral Ozzel who, with a final choke, stumbles and falls in a lifeless heap before him.

INTERIOR: REBEL BASE—MAIN HANGAR DECK

With a sense of urgency, Leia quickly briefs a group of pilots gathered in the center of the hangar.

LEIA: All troop carriers will assemble at the north entrance. The heavy transport ships will leave as soon as they're loaded. Only two fighter escorts per ship. The energy shield can only be opened for a short time, so you'll have to stay very close to your transports.

HOBBIE: Two fighters against a Star Destroyer?

LEIA: The ion cannon will fire several shots to make sure that any enemy ships will be out of your flight path. When you've gotten past the energy shield, proceed directly to the rendezvous point. Understood?

PILOTS: *(in unison)* Right. Okay.

LEIA: Good luck.

DERLIN: Okay. Everybody to your stations. Let's go!

The pilots hurry away.

EXTERIOR: HOTH—ICE PLAIN—SNOW TRENCH—DAY

Rebel troops carry heavy bazooka-type weapons and position them along a snow trench. Men hurriedly respond to their officers' yelled orders and brace themselves against the rhythmic gusts of bitter-cold wind.

Other troops load power packs into a gun turret and swing its guns into position.

EXTERIOR: HOTH—ICE PLAIN—POWER GENERATORS

Near the base power generators, troops rush to set up their heavy battle equipment. Buzzing loudly, the generators send long, sparking fingers of energy into the bitter Hoth wind.

INTERIOR: REBEL BASE—COMMAND CENTER

The long line of Rebel controllers is tense, as are Princess Leia and General Rieekan, who are trying very hard not to show any fear.

RIEEKAN: Their primary target will be the power generators. Prepare to open shield.

EXTERIOR: ICE PLAIN

The Rebel transport and two escort fighters begin their departure from the ice planet.

EXTERIOR: SPACE—IMPERIAL STAR DESTROYER

A huge Imperial Star Destroyer rests against a sea of stars, far above the white surface of the planet Hoth.

INTERIOR: IMPERIAL STAR DESTROYER—BRIDGE

An Imperial controller approaches his commander.

CONTROLLER: Sir, Rebel ships are coming into our sector.

CAPTAIN: Good. Our first catch of the day.

INTERIOR: REBEL BASE—COMMAND CENTER

WOMAN CONTROLLER: Stand by, ion control. . . . Fire!

EXTERIOR: REBEL BASE ICE CAVE—ION CANNON

The giant ball-shaped ion cannon rotates into position and blasts two red energy beams skyward.

EXTERIOR: SPACE—HOTH—REBEL TRANSPORT

The Rebel transport and its escorts race away from the white planet, closely followed by the two red energy beams.

As the Rebel transport races toward the waiting Imperial Star Destroyer, it is overtaken by the two scarlet energy bolts. The Imperial Star Destroyer is hit in the conning tower by the powerful bolts, which set up fiery explosions on its metal hull.

The big Destroyer veers, then spins wildly out of control. As the Imperial ship careens into deep space, the Rebel transport races away to safety.

INTERIOR: REBEL BASE—MAIN HANGAR DECK

Pilots, gunners, and troopers hurry to their stations and their vehicles.

ANNOUNCER: *(over loudspeaker)* The first transport is away.

Everyone cheers at the announcement, which echoes through the hangar. Luke turns and walks on, heading toward his snowspeeder. His gunner, Dack, a fresh-faced, eager kid, is glad to see him. They climb in.

DACK: Feeling all right, sir?

LUKE: Just like new, Dack. How about you?

DACK: Right now I feel like I could take on the whole Empire myself.

LUKE: *(quietly, strapping in)* I know what you mean.

EXTERIOR: HOTH—ICE PLAIN

A thin horizon line cuts across the bleak landscape. Small dot-size objects begin to appear on the horizon, moving in the direction of the Rebel base.

EXTERIOR: HOTH—ICE PLAIN—SNOW TRENCH

A Rebel officer lifts a pair of electrobinoculars to his eyes. Through the lens he sees a very close view of a giant Imperial snow walker. He adjusts the view, which then zooms back to reveal three more of the ominous battle machines. Small flashes of yellow fire billow from the guns of the lumbering snow walkers.

The officer lowers his binoculars as the regular rhythmic pounding begins to make the ground vibrate. The pounding grows louder and is accompanied by a high-pitched, metallic rattling. The officer speaks into his comlink.

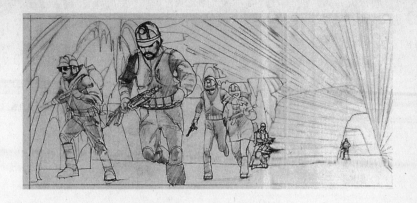

TRENCH OFFICER: Echo Station Three-T-Eight.

INTERIOR: REBEL BASE—CORRIDOR

Pilots and gunners race to their waiting snowspeeders. Ice and snow begin falling from the walls of the corridor, shaken by the pounding Imperial snow walkers as they draw ever nearer.

TRENCH OFFICER: *(over comlink)* We have spotted Imperial walkers!

CONTROLLER: Imperial walkers on the north ridge.

EXTERIOR: HOTH—ICE PLAIN—SNOW TRENCH

The Rebel troops aim their weapons at the horizon as explosions erupt all around them. They are nervous and their grip on their weapons tightens from the cold and from fear.
 Behind the troops a dozen snowspeeders race through the sky.

INTERIOR: LUKE'S SNOWSPEEDER, ROGUE LEADER—COCKPIT

LUKE: *(into comlink)* Echo Station Five-seven. We're on our way.

EXTERIOR: HOTH—ICE PLAIN—BATTLEFIELD

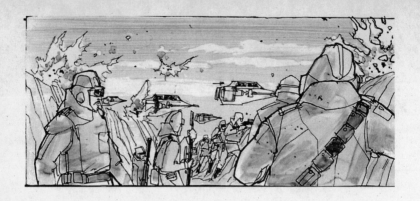

The fleet of snowspeeders races above the ice field at full throttle. They accelerate away from the base and head toward the distant walkers.

INTERIOR: LUKE'S SNOWSPEEDER, ROGUE LEADER—COCKPIT

LUKE: *(into comlink)* All right, boys, keep tight now.

DACK: Luke, I have no approach vector. I'm not set.

LUKE: Steady, Dack. Attack pattern delta. Go now!

EXTERIOR: HOTH—ICE PLAIN—BATTLEFIELD

The cannons mounted on a walker head fire at the speeders. Other walkers loom in the background. Two speeders race away past two of the enormous walkers and bank to the right.

INTERIOR: LUKE'S SNOWSPEEDER, ROGUE LEADER—COCKPIT

LUKE: All right, I'm coming in.

He turns his speeder and heads directly at one of the walkers, flying toward its towering legs. The horizon twists as the speeder banks between the legs.

LUKE: *(into comlink)* Hobbie, you still with me?

EXTERIOR: HOTH—ICE PLAIN—BATTLEFIELD

Two speeders race directly at the head of a walker, then split and fly past it.

Three other walkers march onward, firing all cannons.

EXTERIOR: HOTH—ICE PLAIN—SNOW TRENCH

Rebel troops fire on the approaching walkers, as snow and ice explode all around them.

EXTERIOR: HOTH—ICE PLAIN—BATTLEFIELD

A speeder banks through and away from the legs of a walker. Two other speeders pass the first speeder from the opposite direction. Others of the Rebel craft race just above the icy plain.

A giant walker head swivels and fires, striking a snowspeeder and sending it crashing in a ball of flames.

INTERIOR: IMPERIAL SNOW WALKER—COCKPIT

General Veers and two walker pilots keep a careful eye on the racing Rebel speeders as they maneuver their lumbering war machine forward.

Luke's speeder banks in from the side of Veers's walker and heads straight for its viewport, blasting away. An explosion hits the walker window, but dissipates, doing no harm. The speeder roars up and over the impregnable war machine.

INTERIOR: LUKE'S SNOWSPEEDER, ROGUE LEADER—COCKPIT

Luke looks back at the walker as it grows smaller in the distance.

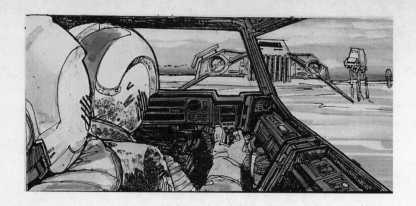

LUKE: That armor's too strong for blasters.

On the horizon, another walker moves up past Luke's cockpit window, twisting out of sight as Luke banks and starts another run.

LUKE: *(into comlink)* Rogue Group, use your harpoons and tow cables. Go for the legs. It might be our only chance of stopping them. *(to Dack)* All right, stand by, Dack.

Dack is at the gunner's controls.

DACK: Luke, we've got a malfunction in fire control. I'll have to cut in the auxiliary.

LUKE: Just hang on. Hang on, Dack. Get ready to fire that tow cable.

Barely keeping his seat in the tumbling ship, Dack struggles to set up his harpoon gun.
 Luke swings his speeder around and heads toward an oncoming walker. Laser bolts and flak fill the air, creating a deadly obstacle course for the tiny craft.

EXTERIOR: HOTH—ICE PLAIN—BATTLEFIELD

Rogue Leader and another snowspeeder fly in tight formation toward the walker as explosions burst all around them.

INTERIOR: LUKE'S SNOWSPEEDER, ROGUE LEADER—COCKPIT

After sustaining a heavy volley of fire, Luke turns around to see if Dack is all right.

LUKE: Dack? Dack!

Dack is lost. Blood streams down his forehead, which rests on his smoldering controls. Out the back window, an Imperial walker recedes in the distance.

EXTERIOR: HOTH—ICE PLAIN—SNOW TRENCH AREA

Rebel troops fire the dishlike ray gun while explosions erupt around them.

EXTERIOR: HOTH—ICE PLAIN—BATTLEFIELD

Two walkers lumber toward the Rebel base as a speeder between them explodes in a ball of flames.

EXTERIOR: HOTH—ICE PLAIN—SNOW TRENCH

The dishlike ray gun is hit by a laser bolt and instantly explodes.

INTERIOR: IMPERIAL SNOW WALKER—COCKPIT

Through the cockpit window, Veers and his pilots can see the Rebel power generators in the distance.
A hologram of Darth Vader appears on a control panel screen.

VEERS: Yes, Lord Vader. I've reached the main power generators. The shield will be down in moments. You may start your landing.

INTERIOR: LUKE'S SNOWSPEEDER, ROGUE LEADER—COCKPIT

LUKE: *(into comlink)* Rogue Three.

INTERIOR: WEDGE'S SNOWSPEEDER, ROGUE THREE—COCKPIT

WEDGE: *(into comlink)* Copy, Rogue Leader.

LUKE: *(over comlink)* Wedge, I've lost my gunner. You'll have to make this shot. I'll cover for you. Set your harpoon. Follow me on the next pass.

WEDGE: *(into comlink)* Coming around, Rogue Leader.

INTERIOR: LUKE'S SNOWSPEEDER, ROGUE LEADER—COCKPIT

LUKE: *(into comlink)* Steady, Rogue Two.

EXTERIOR: HOTH—BATTLEFIELD

Wedge's speeder races through the legs of one of the monstrous walkers.

INTERIOR: WEDGE'S SNOWSPEEDER, ROGUE THREE—COCKPIT

WEDGE: *(to gunner)* Activate harpoon.

Wedge's gunner reaches for a firing switch to activate the harpoon. The harpoon flashes out, and speeds toward the receding legs of the walker.

EXTERIOR: HOTH—BATTLEFIELD

The harpoon hurtles toward the walker. In an instant it is embedded in one of the walker's legs.

INTERIOR: WEDGE'S SNOWSPEEDER, ROGUE THREE—COCKPIT

WEDGE: *(to gunner)* Good shot, Janson.

EXTERIOR: HOTH—BATTLEFIELD

The speeder Rogue Three races around one of the giant walker's feet, trailing the cable behind it. Continuing around the back foot, Rogue Three then circles the walker around the tail end.

INTERIOR: WEDGE'S SNOWSPEEDER, ROGUE THREE—COCKPIT

Wedge checks his controls and banks around the front of the walker.

WEDGE: One more pass.

JANSON: Coming around. Once more.

EXTERIOR: HOTH—BATTLEFIELD

The speeder sweeps left to right in front of the giant legs, towing the cable behind it.

INTERIOR: WEDGE'S SNOWSPEEDER, ROGUE THREE—COCKPIT

JANSON: Once more.

Wedge swings the speeder between the legs of the giant walker.

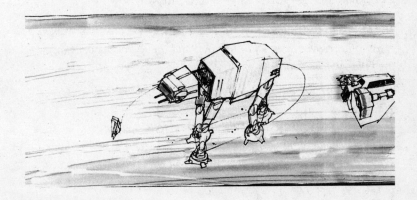

JANSON: Cable out! Let her go!

WEDGE: Detach cable.

EXTERIOR: WEDGE'S SNOWSPEEDER, ROGUE THREE

The cable release on the back of the speeder snaps loose and the cable drops away.

INTERIOR: WEDGE'S SNOWSPEEDER, ROGUE THREE—COCKPIT

JANSON: Cable detached.

EXTERIOR: HOTH—BATTLEFIELD

The speeder zooms away into the distance. The tangled legs of the enormous war machine attempt a step, but as they do the giant Imperial walker begins to topple. It teeters for a moment, and then crashes onto the icy ground, sending snow and metal pieces flying.

EXTERIOR: HOTH—ICE PLAIN—SNOW TRENCH

The troops in the trenches cheer at the sight of the crashing walker.
An officer gives a signal to his men and the Rebel troops charge the fallen war machine.

TRENCH OFFICER: Come on!

The troops run toward the downed walker, followed by two Rebel speeders flying overhead. Just as they reach the walker, it explodes, the impact throwing some of the men onto the frozen ground.

INTERIOR: WEDGE'S SNOWSPEEDER, ROGUE THREE—COCKPIT

Wedge lets out a triumphant yell, banking his speeder away from the fallen walker.

WEDGE: *(into comlink)* Whooha!! That got him!

INTERIOR: LUKE'S SNOWSPEEDER, ROGUE LEADER—COCKPIT

LUKE: *(into comlink)* I see it, Wedge. Good work.

INTEL BASE—COMMAND CENTER

Large chunks of ice tumble into the command center as Leia and General Rieekan monitor computer screens.

RIEEKAN: I don't think we can protect two transports at a time.

LEIA: It's risky, but we can't hold out much longer. We have no choice.

RIEEKAN: *(into comlink)* Launch patrols.

LEIA: *(to an aide)* Evacuate remaining ground staff.

INTERIOR: REBEL BASE—MAIN HANGAR

Muffled distant explosions create widening cracks in the ice roof of the hangar. Trying to ignore the noise and falling bits of snow, Han works on one of the Falcon's lifters while Chewie works on one of the wings. Noticing Chewie attach a wrong part, Han grows impatient.

HAN: No, no! No! This one goes there, that one goes there. Right?

In another area of the hangar, Threepio watches as Artoo is raised up into Luke's X-wing fighter.

THREEPIO: Artoo, you take good care of Master Luke now, understand? And . . . do take good care of yourself. Oh, dear, oh, dear.

EXTERIOR: HOTH—BATTLEFIELD

The fierce battle on the vast snow plains of Hoth rages on. The Imperial walkers continue their slow, steady assault on the Rebel base, firing lasers as they lumber ever onward. In the snow trench, Rebel troops fire large bazookalike guns and dishlike ray guns as explosions erupt around them. A gun tower is hit by a laser bolt and instantly explodes. Another blast destroys a ray gun.

INTERIOR: IMPERIAL SNOW WALKER—COCKPIT

General Veers studies various readouts on his control panel.

VEERS: All troops will debark for ground assault. Prepare to target the main generator.

EXTERIOR: HOTH—BATTLEFIELD

Luke's speeder and Rogue Two fly in formation, banking from right to left and flying above the erupting battlefield. Flak bursts all around them.

INTERIOR: LUKE'S SNOWSPEEDER, ROGUE LEADER—COCKPIT

Luke, glancing over, sees Rogue Two on his left. His ship shudders as flak bursts nearby.

LUKE: *(into comlink)* Rogue Two, are you all right?

INTERIOR: ZEV'S SNOWSPEEDER, ROGUE TWO—COCKPIT

ZEV: *(into comlink)* Yeah. I'm with you, Rogue Leader.

INTERIOR: LUKE'S SNOWSPEEDER, ROGUE LEADER—COCKPIT

LUKE: *(into comlink)* We'll set harpoon. I'll cover for you.

EXTERIOR: HOTH—BATTLEFIELD

The two speeders race across the horizon toward the giant walkers.

INTERIOR: ZEV'S SNOWSPEEDER, ROGUE TWO—COCKPIT

ZEV: *(into comlink)* Coming around.

INTERIOR: LUKE'S SNOWSPEEDER, ROGUE LEADER—COCKPIT

LUKE: *(into comlink)* Watch that crossfire, boys.

INTERIOR: ZEV'S SNOWSPEEDER, ROGUE TWO—COCKPIT

ZEV: *(into comlink)* Set for position three. *(to gunner)* Steady.

LUKE: *(over comlink)* Stay tight and low.

EXTERIOR: ZEV'S SNOWSPEEDER, ROGUE TWO

Luke's speeder moves in formation with Rogue Two, when suddenly Zev's speeder is hit by a laser bolt. His ship bucks violently under the impact and the cockpit explodes in a ball of flame.

Spewing smoke, the speeder hurtles toward a looming walker. Before they collide, Rogue Two explodes in a million flaming pieces.

INTERIOR: LUKE'S SNOWSPEEDER, ROGUE LEADER—COCKPIT

Desperately, Luke works the controls of his flak-buffeted ship. Suddenly, the speeder is rocked by a huge explosion. Luke struggles with the controls with a look of terror on his face. The speeder fills with smoke and electrical sparks jump about the cockpit.

LUKE: *(into comlink)* Hobbie, I've been hit!

INTERIOR: REBEL BASE—COMMAND CENTER

Apart from the distant thunder of laser blasts, the corridor is strangely quiet and empty. Running footsteps echo through the freezing hallway, then Han appears. Cracks have appeared in some of the walls and some pipes have broken, sending hot steam billowing into the underground hallways. Han hurries into the command center. It is a shambles, but some people are still at their posts. As he enters, a gigantic cave-in almost obliterates the room. He finds Leia and Threepio near one of the control boards.

HAN: You all right?

Leia nods. She is surprised to see him.

LEIA: Why are you still here?

HAN: I heard the command center had been hit.

LEIA: You got your clearance to leave.

HAN: Don't worry, I'll leave. First I'm going to get you to your ship.

THREEPIO: Your Highness, we must take this last transport. It's our only hope.

LEIA: *(to controller)* Send all troops in sector twelve to the south slope to protect the fighters.

A blast rocks the command center, throwing Threepio backward into Han's arms.

ANNOUNCER: *(over loudspeaker)* Imperial troops have entered the base.

HAN: Come on . . . that's it.

LEIA: *(to head controller)* Give the evacuation code signal. And get to your transports!

Leia looks exhausted. Han grabs her hand and starts to lead her out.

 As Han, Leia, and Threepio run out of the command center, the code signal can be heard echoing off the corridor walls.

HEAD CONTROLLER: K-one-zero . . . all troops disengage

THREEPIO: *(to Han and Leia)* Oh! Wait for me!

EXTERIOR: BATTLEFIELD—SNOW TRENCH

Rebel troops retreat under the awesome Imperial onslaught.

OFFICER: Begin retreat!

SECOND OFFICER: Fall back!

Troops flee from the battle, the ground exploding around them.

EXTERIOR: HOTH—BATTLEFIELD

Three of the giant walkers, firing lasers, advance toward the Rebel headquarters.

EXTERIOR: HOTH—SNOW TRENCH

Continuing their retreat, the Rebels see the walkers looming ever nearer.

EXTERIOR: HOTH—BATTLEFIELD—ICE PLAIN

On the battlefield, Luke watches as a walker foot rises and moves over him. He looks up at the underbelly of the huge walker, passing overhead.

Running beneath the monstrous machine, Luke fires his harpoon gun at the walker's underside. A thin cable follows the projectile from the gun. The magnetic head and cable attach firmly to the metal hull.

Still running under the walker, Luke attaches the cable drum to his belt buckle. Soon he is pulled up the cable and hangs dangling underneath the walker.

The walker's giant feet continue to pound onward across the frozen snow. Stray laser bolts whistle by Luke as he climbs up the cable to the walker's hull, reaching a small hatch. Hanging precariously, Luke cuts the solid metal hatch with his laser sword.

He takes a land mine from around his neck and throws it inside the Imperial machine. Quickly, Luke starts down the cable and crashes onto the icy ground far below. He lies unconscious as a giant rear leg passes by—and just misses him.

The giant walker stops in midstep. A muffled explosion comes from within—and then the walker's mechanical insides are spewed out of every conceivable opening. The machine sits dead in its tracks, smoking like a locomotive on stilts.

EXTERIOR: HOTH—BATTLEFIELD

Veers's walker continues to advance toward the Rebel base. The smoldering walker that Luke exploded stands smoking just to the right of Veers's path.

INTERIOR: IMPERIAL SNOW WALKER—COCKPIT

Inside his walker, General Veers prepares to fire on the Rebel power generators.

VEERS: Distance to power generators?

PILOT: One-seven, decimal two-eight.

Veers reaches for the electrorangefinder and lines up the main generator.

VEERS: Target. Maximum fire power.

EXTERIOR: HOTH—BATTLEFIELD

The Rebel troops continue their desperate retreat, pushed back by the relentless Imperial assault.

INTERIOR: HOTH—REBEL BASE—ICE CORRIDORS

With Threepio lagging behind, Han and Leia race through the crumbling ice corridors. Suddenly, there is an explosion. Han turns, grabs the princess, and pulls her to the wall as a tremendous cave-in blocks their path.
He takes the comlink from his pocket.

HAN: *(into comlink)* Transport, this is Solo. Better take off—I can't get to you. I'll get the princess out on the *Falcon.*

Han and Leia turn and race down the corridor.

THREEPIO: But . . . but . . . but . . . where are you going? Uh . . . come back!!

INTERIOR: HOTH—REBEL BASE—COMMAND CENTER

Imperial troops have reached the base. As they push through the blocked passageway, Darth Vader strides behind them.

INTERIOR: HOTH—REBEL BASE—ICE CORRIDOR

Han and Leia run toward the entrance of the main hangar where the Millennium Falcon *is docked. Threepio still lags behind.*

THREEPIO: Wait! Wait for me! Wait! Stop!

The door to the hangar closes in his face.

THREEPIO: *(exasperated)* How typical.

Quickly, the door reopens as Han reaches out and pulls the golden droid through.

HAN: Come on.

INTERIOR: HOTH—REBEL BASE—MAIN HANGAR

Chewie paces under the shelter of the Millennium Falcon's *landing gear. The giant Wookiee pats the underbelly of his beloved ship and barks a few reassuring words. As he searches worriedly for his captain, something at last catches his eye.*

 Chewie lets out a relieved shriek at seeing Han and Leia running toward the ship. The Wookiee runs out into the falling ice, lets out a howl, then runs up the ship's ramp. Han and Leia run up the ramp after him, closely followed by Threepio.

HAN: Hurry up, goldenrod, or you're going to be a permanent resident!

THREEPIO: Wait! Wait!

INTERIOR: HOTH—REBEL BASE—ICE CORRIDOR

Imperial troops run through the base corridors. Vader surveys the place. A huge ice chunk falls, almost hitting him, but he calmly, purposefully, continues around it.

INTERIOR: REBEL BASE—MAIN HANGAR—MILLENNIUM FALCON

A distant, huge explosion rocks the hangar deck. Ice cakes come crashing down on the Millennium Falcon.

INTERIOR: MAIN HANGAR—MILLENNIUM FALCON—MAIN HOLD

Han, standing before a control panel, is busy flipping switches as Chewie watches a troublesome gauge. A worried Leia observes their efforts.

HAN: *(to Chewie)* How's this?

The Wookiee barks a negative reply.

LEIA: Would it help if I got out and pushed?

HAN: It might.

Threepio clanks into the hold.

THREEPIO: Captain Solo, Captain Solo . . . sir, might I suggest that you . . .

Han gives the gold robot a devastating look.

THREEPIO: It can wait.

INTERIOR: MAIN HANGAR—MILLENNIUM FALCON—COCKPIT

They move to the cockpit where Han flips some more switches. Leia watches him, impatient, disbelieving.

LEIA: This bucket of bolts is never going to get us past that blockade.

HAN: This baby's got a few surprises left in her, sweetheart.

Han and Leia look out the cockpit window and see a squad of stormtroopers rushing into the far side of the hangar.
 Quickly, Han straps himself into the pilot's seat and Leia gets into the navigator's chair.

INTERIOR: HOTH—REBEL BASE—MAIN HANGAR

Stormtroopers hurriedly set up a large bazookalike weapon. Behind them the giant hangar doors open slowly.

EXTERIOR: MAIN HANGAR—MILLENNIUM FALCON

A laser gun appears on the Falcon *and swings around to aim at the Imperial troops.*

 The stormtroopers, preparing to fire their bazooka cannon, are hit by the Falcon's *fire and are thrown about in all directions.*

INTERIOR: MAIN HANGAR—MILLENNIUM FALCON—COCKPIT

Chewie rushes into the cockpit.

HAN: Come on! Come on! Switch over. Let's hope we don't have a burnout.

A laser hits the window near Chewie as he is settling into his chair. Letting out a loud whelp, Chewie quickly pulls back on the controls and the first stage of engine fire can be heard. Han flashes a big grin at Leia.

HAN: See?

LEIA: Someday you're going to be wrong, and I just hope I'm there to see it.

Han looks at Chewie.

HAN: Punch it!

The roar of the Falcon's *main engines blasts out everything as the ice-cave wall rushes by outside the cockpit window.*

INTERIOR: REBEL BASE—MAIN HANGAR

More stormtroopers run into the hangar, closely followed by Vader.

Hearing the loud roar of the Millennium Falcon's *engines, Vader looks toward the main hangar doors just in time to see the* Falcon *lift up and disappear outside the cave.*

EXTERIOR: HOTH—ICE SLOPE—DAY

Luke and two other pilots look up as the Millennium Falcon *races above them, flying very close to the ground.*

The three pilots turn then, and trudge onward toward their X-wing fighters, each going to his own ship. Luke waves farewell, then heads toward his own fighter.

Artoo, seated in his cubbyhole, chirps an excited greeting as Luke climbs aboard the spacecraft.

LUKE: Artoo! Get her ready for takeoff.

From his ship, Luke sees Wedge in his own X-wing, preparing for takeoff.

WEDGE: Good luck, Luke. See you at the rendezvous.

Luke smiles and nods at Wedge, then lowers himself into the cockpit of his X-wing while Artoo waits in the cubbyhole, beeping impatiently.

LUKE: Don't worry, Artoo. We're going, we're going.

The canopy over the X-wing lowers and snaps shut.

EXTERIOR: SPACE—LUKE'S X-WING

Luke's fighter, its wings closed, speeds away from the icy planet. Soon it disappears into the stars.

INTERIOR: LUKE'S X-WING—COCKPIT

Luke, looking thoughtful, suddenly makes a decision. He flips several switches. The stars shift as he takes his fighter into a steep turn. The X-wing banks sharply and flies away in a new direction.

The monitor screen on Luke's control panel prints out a question from the concerned Artoo.

LUKE: *(into comlink)* There's nothing wrong, Artoo. I'm just setting a new course.

Artoo beeps once again.

LUKE: *(into comlink)* We're not going to regroup with the others.

Artoo begins a protest, whistling an unbelieving, "What?!"
Luke reads Artoo's exclamation on his control panel.

LUKE: *(into comlink)* We're going to the Dagobah system.

Luke checks his readouts and makes a few adjustments. He rides along with only the soft hum of the instruments to break the silence. Finally, Artoo chirps up.

LUKE: *(into comlink)* Yes, Artoo?

Artoo utters a soft, carefully phrased stream of whistles.

LUKE: *(into comlink, chuckling)* That's all right. I'd like to keep it on manual control for a while.

The little droid lets out a defeated whimper. Luke just smiles, and continues on his course.

EXTERIOR: SPACE—MILLENNIUM FALCON

The Millennium Falcon *speeds away from Hoth, closely followed by one huge Star Destroyer and four tiny TIE fighters.*

As it is pursued, the Falcon *races toward two very bright star-size objects.*

INTERIOR: MILLENNIUM FALCON—COCKPIT

Inside the cockpit, Chewie lets out a loud howl. Han checks the deflectors as the ship is buffeted by exploding flak. He appears to be doing six things at once.

HAN: *(harried)* I saw them! I saw them!

LEIA: Saw what?

HAN: Star Destroyers, two of them, coming right at us.

Threepio bumps and bangs his way into the cockpit.

THREEPIO: Sir, sir! Might I suggest . . .

HAN: *(to Leia)* Shut him up or shut him down! *(to Chewie)* Check the deflector shield!

Chewie barks a reply as he readjusts an overhead switch.

HAN: Oh, great. Well, we can still outmaneuver them.

EXTERIOR: SPACE—MILLENNIUM FALCON—STAR DESTROYERS

The Millennium Falcon *races toward one of the huge oncoming Star Destroyers. Suddenly, the* Falcon *starts into a steep dive straight down, closely followed by four TIE fighters. The underside of the Star Destroyer continues on a collision course with the two oncoming Star Destroyers. Slowly, it starts to veer to the left.*

INTERIOR: STAR DESTROYER—BRIDGE

Out the front window, the two approaching Star Destroyers can be seen veering to the left.

IMPERIAL OFFICER: Take evasive action!

Alarms sound all over the huge ship. The two other Star Destroyers get closer, one of them moving over the bridge so close that it makes brushing contact with it.

EXTERIOR: SPACE—MILLENNIUM FALCON—TIE FIGHTERS

The Millennium Falcon *races away from the colliding Star Destroyers, still followed by four TIE fighters. Laser bolts spark the pitch-black skies.*

INTERIOR: MILLENNIUM FALCON—COCKPIT

Things have calmed down a bit, but the race isn't over yet. Chewie barks at Han. Leia is still trying to recover from the steep dive. The ship is buffeted by laser blasts.

HAN: Prepare to make the jump to light-speed.

THREEPIO: But, sir!

The buffeting of the lasers becomes louder and stronger.

LEIA: They're getting closer!

HAN: *(with a gleam in his eye)* Oh, yeah? Watch this.

Expectantly, they look out the cockpit window as stars do not go into hyperspace, but just sit there.
Han and Chewie look at each other and are thrown into an acute state of concern.

LEIA: Watch what?

Han tries again. Still nothing.

HAN: I think we're in trouble.

THREEPIO: If I may say so, sir, I noticed earlier the hyperdrive motivator has been damaged. It's impossible to go to light-speed!

HAN: We're in trouble!

The explosions become heavier.

EXTERIOR: SPACE—MILLENNIUM FALCON—TIE FIGHTERS—STAR
DESTROYER

The Falcon *races into the starry vastness, followed by the four
Imperial TIE fighters and an Imperial Star Destroyer.*

INTERIOR: MILLENNIUM FALCON—COCKPIT

Stars race by as flak bursts outside the Falcon's *window.*

INTERIOR: MILLENNIUM FALCON—HOLD

*Han works furiously at some control panels while giving various
orders to Chewie.*

HAN: Horizontal boosters . . . !

(Chewie barks)

Alluvial dampers . . . ! Well, that's not it.

(Chewie barks)

Bring me the hydrospanners!

Chewie hurries over to the pit and places the tools on the edge.

HAN: I don't know how we're going to get out of this one.

Suddenly, a loud thump hits the side of the Falcon, *causing it to
lurch radically. Chewie barks. The tools fall into the pit on top of Han.*

HAN: Oww! Chewie!

More turbulence rocks the ship.

HAN: That was no laser blast! Something hit us.

LEIA: *(over comlink)* Han, get up here!

HAN: Come on, Chewie!

Han climbs out of the hold like a shot. Both he and Chewie run out of the hold and toward the cockpit.

INTERIOR: MILLENNIUM FALCON—COCKPIT

Out the front cockpit window, they see hundreds of asteroids racing by.

LEIA: Asteroids!

Han changes places with Leia who has been at the controls, and Chewie gets into his chair. Han works his controls as a chunk of rock crosses in front of the ship.

HAN: Oh, no! Chewie, set two seven-one.

LEIA: What are you doing? You're not actually going into an asteroid field?

HAN: They'd be crazy to follow us, wouldn't they?

Another asteroid thumps against the ship and Leia winces at the jolt.

LEIA: You don't have to do this to impress me.

THREEPIO: Sir, the possibility of successfully navigating an asteroid field is approximately three thousand, seven hundred and twenty to one.

HAN: Never tell me the odds!

EXTERIOR: ASTEROID BELT—MILLENNIUM FALCON

The Falcon *turns into the asteroid storm and as the ship completes its turn, asteroids start coming straight at the cockpit window.*

A large asteroid tumbles away from the Falcon's path at top speed. Several smaller asteroids crash into the big one, creating small explosions on its surface. Other asteroids of all sizes pass by in every direction, some colliding and exploding. The tiny Millennium Falcon veers around the big asteroid and races past it through the rain of rocks, followed by four TIE fighters, which bob and weave around the asteroids.

One of the pursuing TIE fighters connects with an asteroid and explodes. The other fighters are pelted with a steady stream of smaller explosions.

Two huge asteroids tumble toward the Millennium Falcon, which quickly banks around both of them. The three TIE fighters follow in hot pursuit until one of the fighters scrapes an asteroid and tumbles out of control into deep space.

EXTERIOR: SPACE—STAR DESTROYER—ASTEROID BELT

The massive Star Destroyer blasts oncoming asteroids as it follows the Falcon. Smaller asteroids explode across its vast surface.

EXTERIOR: MILLENNIUM FALCON—TIE FIGHTERS—
ASTEROID BELT

The Falcon *twists on its side as it races around an oncoming asteroid. Two TIE fighters follow in the distance, coming from either side.*

INTERIOR: MILLENNIUM FALCON—COCKPIT

Asteroids race by the cockpit window as Han pilots his trusty craft through the dangerous field.

Looking out the cockpit window, the Falcon *crew sees a big asteroid drop past the window, narrowly missing their ship.*

Chewie barks in terror as a slightly smaller asteroid comes especially close—too close—and bounces off the Falcon *with a loud crunch. Threepio's hands cover his eyes. He manages a short peek at the cockpit window. Princess Leia sits stone-faced, staring at the action. Han gives her a quick look.*

HAN: You said you wanted to be around when I made a mistake; well, this could be it, sweetheart.

LEIA: I take it back. We're going to get pulverized if we stay out here much longer.

The group watches as more asteroids race by outside the window.

HAN: I'm not going to argue with that.

THREEPIO: Pulverized?

HAN: I'm going in closer to one of those big ones.

LEIA: Closer?

THREEPIO: Closer?!

Chewbacca barks the same word, only louder.

EXTERIOR: MILLENNIUM FALCON—ASTEROID BELT

The Millennium Falcon *dives toward the surface of one of the moon-size asteroids. There is a continued display of explosions against the starry void as smaller asteroids collide with larger chunks of rock. The two remaining TIE fighters follow the* Falcon *to the large asteroid. The* Falcon *skims the surface of the giant asteroid as, all the while, small asteroids explode on the surface of the ship.*

The TIE fighters approach the Falcon, *but a giant asteroid hurtles directly into their path. As the asteroid continues on its way, it leaves the remains of the two exploded TIE fighters to tumble into deep space.*

INTERIOR: MILLENNIUM FALCON—COCKPIT

Rattled by the violent rocking of the starship, Threepio is nearly in hysterics.

THREEPIO: Oh, this is suicide!

Han notices something on his main scope and nudges his faithful Wookiee, pointing.

HAN: There. That looks pretty good.

LEIA: What looks pretty good?

HAN: Yeah. That'll do nicely.

THREEPIO: *(to Leia)* Excuse me, ma'am, but where are we going?

Out the cockpit window, they see that they are skimming the surface of the enormous asteroid and nearing a large crater.

EXTERIOR: MILLENNIUM FALCON—GIANT ASTEROID CRATER

The Millennium Falcon *dives into the huge crater and disappears.*

INTERIOR: MILLENNIUM FALCON—COCKPIT

LEIA: I hope you know what you're doing.

HAN: Yeah, me too.

INTERIOR: GIANT ASTEROID CRATER

The Falcon *races down into the crater. The walls are barely visible as the ship speeds through the tunnel-like opening. A small cave appears on one side of the crater, and the* Falcon *turns, slows, and scoots into it.*

EXTERIOR: SPACE—LUKE'S X-WING

The tiny X-wing speeds toward the cloud cover of Dagobah. Artoo, riding on the back of the fighter, turns his head back and forth with some anxiety.

INTERIOR: LUKE'S X WING COCKPIT

Luke watches Artoo's words as they are translated and screened on the computer scope.

LUKE: *(into comlink)* Yes, that's it. Dagobah.

Artoo beeps a hopeful inquiry.

LUKE: *(into comlink)* No, I'm not going to change my mind about this. *(getting a little nervous)* I'm not picking up any cities or technology. Massive life-form readings, though. There's something alive down there . . .

Again, Artoo beeps, this time a slightly worried question.

LUKE: *(into comlink)* Yes, I'm sure it's perfectly safe for droids.

EXTERIOR: SPACE—DAGOBAH—LUKE'S X-WING

The X-wing continues its flight through the twilight above the cloud-covered planet.

INTERIOR: LUKE'S X-WING—COCKPIT

Luke sees the clouds race by as he takes his craft closer to the planet. He must operate his controls carefully since the cloud cover has completely obscured his vision. An alarm buzzes in the background. Artoo beeps and whistles frantically.

LUKE: *(into comlink)* I know, I know! All the scopes are dead. I can't see a thing! Just hang on, I'm going to start the landing cycle . . .

The blast of the retrorockets is deafening, drowning out Artoo's electronic squeals. Suddenly, there is a cracking sound as if limbs were being broken off trees and then a tremendous jolt as the spacecraft stops. Luke pulls a switch and his canopy pops open.

EXTERIOR: DAGOBAH—DUSK

The mist-shrouded X-wing fighter is almost invisible in the thick fog. Luke climbs out onto the long nose of the spacecraft as Artoo pops out of his cubbyhole on the back. The young warrior surveys the fog, which is barely pierced by the ship's landing lights. About all he can make out are some giant, twisted trees nearby. Artoo whistles anxiously.

LUKE: No, Artoo, you stay put. I'll have a look around.

Artoo lets out a short beep. As Luke moves along the nose, Artoo loses his balance and disappears with a splash into the boggy lake.

LUKE: Artoo?

Luke kneels and leans over the plane looking for Artoo, but the water is still and reveals no sign of the little droid.

LUKE: Artoo! Where are you?

A small periscope breaks the surface of the water and a gurgly beep is heard. The periscope starts to move to shore. Relieved, Luke starts running along the nose of the fighter to its tip.

LUKE: Artoo! You be more careful.

The outline of the shore is now no more than ten feet away. Luke jumps off the plane into the water, scrambles up to the shore, and turns to look for Artoo. The periscope still steadily moves toward shore.

LUKE: Artoo—that way!

Suddenly, through the thick fog layer, a dark shape appears, moving toward the little droid. The dark, sinuous bog beast dives beneath the swampy water, making a loud clunk against Artoo's metal hull. The droid disappears from sight, uttering a pathetic electronic scream.

Holding his ignited lightsaber before him, Luke wades a few feet into the murky pool, looking for any sign of his little friend.

LUKE: Artoo!

The black surface is still as death itself . . . until a few bubbles begin to appear. Then, phheewaat!! *The runt-size robot is spit out of the water, makes a graceful arc, and comes crashing down into a patch of soft gray moss.*

LUKE: Oh, no! Are you all right? Come on. You're lucky you don't taste very good. Anything broken?

Luke helps Artoo to his feet and begins wiping the mud and roots from his round metal body. Artoo responds with feeble, soggy beeps.

LUKE: If you're saying coming here was a bad idea, I'm beginning to agree with you. Oh, Artoo, what are we doing here? It's like . . . something out of a dream, or, I don't know. Maybe I'm just going crazy.

*As Luke glances around at the spooky swamp jungle that surrounds
him, Artoo ejects a stream of muddy water from one of his cranial ports.*

EXTERIOR: VADER'S STAR DESTROYER—VADER'S CHAMBER

*Admiral Piett hesitates in the entryway to Vader's private cubicle.
After a moment, he steps into the room and pauses at the surprising
sight before him.*

 *Darth Vader, his back turned, is silhouetted in the gloom on the far
side of the chamber. A black, insectlike droid attends him. Among the
various apparatuses surrounding them, a respirator tube now
retracts from Vader's uncovered head. The head is bald with a mass
of ugly scar tissue covering it. The black droid then lowers the mask
and helmet onto Vader's head. When it is in place, the Dark Lord
turns to face Piett.*

VADER: Yes, Admiral?

PIETT: Our ships have sighted the *Millennium Falcon*, Lord. But . . . it
has entered an asteroid field and we cannot risk . . .

VADER: *(interrupting)* Asteroids do not concern me, Admiral. I want
that ship and not excuses.

PIETT: Yes, Lord.

EXTERIOR: ASTEROID CAVE—MILLENNIUM FALCON

*The pirate starship rests in a dark, dripping asteroid cave. It is so
dark that the cave's exact dimensions are impossible to determine.*

INTERIOR: MILLENNIUM FALCON—COCKPIT

*Han and Chewie busily shut down the engine and all electronic
systems. Threepio and Leia watch worriedly.*

HAN: I'm going to shut down everything but the emergency power systems.

THREEPIO: Sir, I'm almost afraid to ask, but . . . does that include shutting me down, too?

Chewie barks "yes." But Han thinks otherwise.

HAN: No, I need you to talk to the *Falcon*, find out what's wrong with the hyperdrive.

Suddenly, the ship lurches, causing all the loose items in the cockpit to go flying. Chewie howls.

THREEPIO: Sir, it's quite possible this asteroid is not entirely stable.

HAN: Not entirely stable? I'm glad you're here to tell us these things. Chewie, take the professor in the back and plug him into the hyperdrive.

THREEPIO: Oh! Sometimes I just don't understand human behavior. After all, I'm only trying to do my job in the most . . .

The sliding door closes behind the indignant Threepio as Chewie and he move back to the hold. Suddenly, the ship lurches again, throwing Leia across the cabin into Han's arms. Then, abruptly, the motion stops as suddenly as it started. With some surprise, Han and Leia realize they are in each other's arms.

LEIA: Let go.

HAN: Sshh!

LEIA: Let go, please.

Leia flushes, averting her eyes. She's not exactly fighting to get free. But, of course, Han blows it . . .

HAN: Don't get excited.

The anger rises in Leia.

LEIA: Captain, being held by you isn't quite enough to get me excited.

HAN: Sorry, sweetheart. We haven't got time for anything else.

Han grins wickedly at Leia as he turns and exits through the door. Leia's confused emotions show clearly on her lovely face.

EXTERIOR: DAGOBAH—BOG CLEARING—DUSK

The mist has dispersed a bit, but it is still a very gloomy-looking swamp.

Luke pulls an equipment box from the shore to the clearing. He ignites a little fusion furnace and warms his hands before it. Taking a power cable, he plugs it into Artoo's noselike socket.

LUKE: Ready for some power? Okay. Let's see now. Put that in there. There you go.

The droid whistles his appreciation. Luke then opens a container of processed food and sits before the thermal heater.

LUKE: *(sighs)* Now all I have to do is find this Yoda . . . if he even exists.

Nervously, he looks around at the foreboding jungle.

LUKE: It's really a strange place to find a Jedi Master. It gives me the creeps.

Artoo beeps in agreement with that sentiment.

LUKE: Still . . . there's something familiar about this place. I feel like . . . I don't know . . .

STRANGE VOICE: Feel like what?

Luke jumps out of his skin. Artoo screeches in terror. The young warrior grabs for his lightsaber as he spins around, looking for the speaker. Mysteriously standing right in front of Luke is a strange,

*bluish creature, not more than two feet tall. The wizened little thing
is dressed in rags. It motions toward Luke's sword.*

LUKE: *(looking at the creature)* Like we're being watched!

CREATURE: Away put your weapon! I mean you no harm.

*After some hesitation, Luke puts away his weapon, although he really
doesn't understand why. Artoo watches with interest.*

CREATURE: I am wondering, why are you here?

LUKE: I'm looking for someone.

CREATURE: Looking? Found someone, you have, I would say, hmmm?

The little creature laughs.

LUKE: *(trying to keep from smiling)* Right.

CREATURE: Help you I can. Yes, mmmm.

LUKE: I don't think so. I'm looking for a great warrior.

CREATURE: Ahhh! A great warrior. *(laughs and shakes his head)* Wars
not make one great.

*With the aid of a walking stick, the tiny stranger moves over to one of
the cases of supplies. He begins to rummage around.*

*Artoo moves to the edge of the case—standing almost eye level to
the creature who is carelessly handling the supplies—and squeaks
his disapproval.*

*Their tiny visitor picks up the container of food Luke was eating
from and takes a bite.*

LUKE: Put that down. Hey! That's my dinner!

The creature spits out the bite he has taken. He makes a face.

CREATURE: How you get so big, eating food of this kind?

He flips the container in Luke's direction and reaches into one of Luke's supply cases.

LUKE: Listen, friend, we didn't mean to land in that puddle, and if we could get our ship out, we would, but we can't, so why don't you just . . .

CREATURE: *(teasing)* Aww, cannot get your ship out?

The creature starts rummaging through Luke's case, throwing the contents out behind him.

LUKE: Hey, get out of there!

CREATURE: Ahhh! No!

The creature spots something of interest in Luke's case. Luke loses patience and grabs the case away. The creature retains his prize—a tiny power lamp—and examines it with delight.

LUKE: Hey, you could have broken this. Don't do that. Ohhh . . . you're making a mess. Hey, give me that!

CREATURE: *(retreating with the lamp)* Mine! Or I will help you not.

Clutching its treasure, the creature backs away from Luke, drawing closer to Artoo. As Luke and the creature argue, one of Artoo's little arms slowly moves out toward the power lamp, completely unnoticed by the creature.

LUKE: I don't want your help. I want my lamp back. I'll need it to get out of this slimy mudhole.

CREATURE: Mudhole? Slimy? My home this is.

Artoo grabs hold of the lamp and the two little figures are immediately engaged in a tug-of-war over it.
 Artoo beeps a few angry, "Give me thats."

CREATURE: Ah, ah, ah!

LUKE: Oh, Artoo, let him have it.

CREATURE: Mine! Mine!

LUKE: Artoo!

CREATURE: Mine!

The creature lets go with one hand and pokes Artoo lightly with one finger. Artoo reacts with a startled squeal, and lets go.

CREATURE: Mine!

LUKE: *(fed up)* Now will you move along, little fella? We've got a lot of work to do.

CREATURE: No! No, no! Stay and help you, I will. *(laughs)* Find your friend, hmm?

LUKE: I'm not looking for a friend, I'm looking for a Jedi Master.

CREATURE: Oohhh. Jedi Master. Yoda. You seek Yoda.

LUKE: You know him?

CREATURE: Mmm. Take you to him, I will. *(laughs)* Yes, yes. But now, we must eat. Come. Good food. Come.

With that, the creature scurries out of the clearing, laughing merrily. Luke stares after him. All he sees is the faint light from the small power lamp moving through the fog. Luke makes his decision and starts after the creature.

CREATURE: *(in the distance)* Come, come.

Artoo, very upset, whistles a blue streak of protests.

LUKE: Stay here and watch after the camp, Artoo.

Artoo beeps even more frantically. But as Luke disappears from view, the worried little droid grows quieter, and utters a soft electronic sigh.

INTERIOR: MILLENNIUM FALCON—MAIN HOLD AREA

Threepio whistles and beeps a strange dialect into the control panel in front of him. The control panel whistles back a few mystifying beeps.

THREEPIO: Oh, where is Artoo when I need him?

Han enters the hold area and kneels on the floor near the control box.

THREEPIO: Sir, I don't know where your ship learned to communicate, but it has the most peculiar dialect. I believe, sir, it says that the power coupling on the negative axis has been polarized. I'm afraid you'll have to replace it.

HAN: Well, of course I'll have to replace it.

He hands a wire coil up to Chewie who is working near the ceiling.

HAN: Here! And, Chewie . . .

Chewie brings his head back through the trap door in the ceiling and whines. Han glances back at Threepio, then speaks quietly to Chewie so only he can hear.

HAN: *(continued)* . . . I think we'd better replace the negative power coupling.

Leia finishes welding the valve she has been working on and attempts to reengage the system by pulling a lever attached to the valve. It doesn't budge. Han notices her struggle, and moves to help her. She rebuffs him.

HAN: Hey, Your Worship, I'm only trying to help.

LEIA: *(still struggling)* Would you please stop calling me that?

Han hears a new tone in her voice. He watches her pull on the lever.

HAN: Sure, Leia.

LEIA: Oh, you make it so difficult sometimes.

HAN: I do, I really do. You could be a little nicer, though. *(he watches her reaction)* Come on, admit it. Sometimes you think I'm all right.

She lets go of the lever and rubs her sore hand.

LEIA: Occasionally *(a little smile, haltingly)* maybe . . . when you aren't acting like a scoundrel.

HAN: *(laughs)* Scoundrel? Scoundrel? I like the sound of that.

With that, Han takes her hand and starts to massage it.

LEIA: Stop that.

HAN: Stop what?

Leia is flushed, confused.

LEIA: Stop that! My hands are dirty.

HAN: My hands are dirty, too. What are you afraid of?

LEIA: *(looking right into his eyes)* Afraid?

Han looks at her with a piercing look. He's never looked more handsome, more dashing, more confident. He reaches out slowly and takes Leia's hand again from where it is resting on a console. He draws it toward him.

HAN: You're trembling.

LEIA: I'm not trembling.

Then with an irresistible combination of physical strength and emotional power, the space pirate begins to draw Leia toward him . . . very slowly.

HAN: You like me *because* I'm a scoundrel. There aren't enough scoundrels in your life.

Leia is now very close to Han and as she speaks, her voice becomes an excited whisper, a tone completely in opposition to her words.

LEIA: I happen to like nice men.

HAN: I'm a nice man.

LEIA: No, you're not. You're . . .

He kisses her now, with slow, hot lips. He takes his time, as though he had forever, bending her body backward. She has never been kissed like this before, and it almost makes her faint. When he stops, she regains her breath and tries to work up some indignation, but finds it hard to talk.

Suddenly, Threepio appears in the doorway, speaking excitedly.

THREEPIO: Sir, sir! I've isolated the reverse power flux coupling.

Han turns slowly, icily, from their embrace.

HAN: Thank you. Thank you very much.

THREEPIO: Oh, you're perfectly welcome, sir.

The moment spoiled, Han marches out after Threepio.

EXTERIOR: SPACE—ASTEROID FIELD

The Imperial fleet moves through the asteroid-filled void, intently seeking its prey.

INTERIOR: VADER'S STAR DESTROYER—BRIDGE

Asteroids collide, creating a fireworks display outside the bridge window. Darth Vader stands, staring out the window above the control deck. Then he slowly turns toward the bridge. Before him are the hologram images of twenty battleship commanders. One of these images, the commander of a ship that has just exploded, is fading quickly away. Another image,

in the center and a little apart from the others, is faded and continually disrupted by static. It is the image of Captain Needa, commander of the Star Destroyer most hotly on the tail of the Millennium Falcon. *Admiral Piett and an aide stand behind the Dark Lord.*

NEEDA: *(in hologram)* . . . and that, Lord Vader, was the last time they appeared in any of our scopes. Considering the amount of damage we've sustained, they must have been destroyed.

VADER: No, Captain, they're alive. I want every ship available to sweep the asteroid field until they are found.

The Imperial star captains fade out one by one as Vader turns to Admiral Piett.

PIETT: Lord Vader.

VADER: Yes, Admiral, what is it?

The admiral is scared, his face white as a sheet.

PIETT: The Emperor commands you to make contact with him.

VADER: Move the ship out of the asteroid field so that we can send a clear transmission.

PIETT: Yes, my lord.

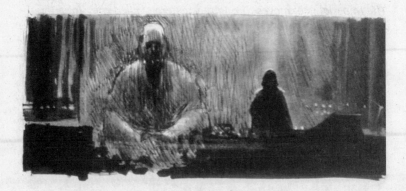

EXTERIOR: ASTEROID FIELD—VADER'S STAR DESTROYER

Vader's Imperial Star Destroyer moves against the vast sea of stars away from the rest of the fleet.

INTERIOR: VADER'S STAR DESTROYER—VADER'S CHAMBER

The Dark Lord, Darth Vader, is alone in his chamber. A strange sound enters the room and light begins to play across Vader's black figure. He looks up and bows quickly.

A twelve-foot hologram of the Galactic Emperor materializes before Vader. The Emperor's dark robes and monk's hood are reminiscent of the cloak worn by Ben Kenobi. His voice is even deeper and more frightening than Vader's.

VADER: What is thy bidding, my master?

EMPEROR: There is a great disturbance in the Force.

VADER: I have felt it.

EMPEROR: We have a new enemy—Luke Skywalker.

VADER: Yes, my master.

EMPEROR: He could destroy us.

VADER: He's just a boy. Obi-Wan can no longer help him.

EMPEROR: The Force is strong with him. The son of Skywalker must not become a Jedi.

VADER: If he could be turned, he would become a powerful ally.

EMPEROR: Yes. Yes. He would be a great asset. Can it be done?

VADER: He will join us or die, my master.

Vader kneels. The supreme Emperor passes a hand over the crouched Lord of the Sith and fades away.

EXTERIOR: DAGOBAH—CREATURE'S HOUSE—NIGHT

A heavy downpour of rain pounds through the gnarled trees. A strange baroque mud house sits on a moss-covered knoll on the edge

*of a small lagoon. The small, gnomish structure radiates a warm
glow from its thick glass windows. As the rain tap-dances a merry
tune on Artoo's head, the stubby little droid rises up on his tip-toes
to peek into one of the glowing portals.*

INTERIOR: CREATURE'S HOUSE

*Artoo, peeking in the window, sees the inside of the house—a very
plain, but cozy dwelling. Everything is in the same scale as the
creature. The only thing out of place in the miniature room is Luke,
whose height makes the four-foot ceiling seem even lower. He sits
cross-legged on the floor of the living room.*

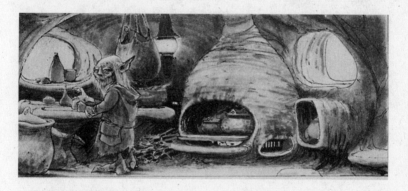

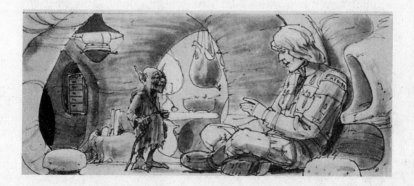

The creature is in an adjoining area—his little kitchen—cooking up an incredible meal. The stove is a steaming hodgepodge of pots and pans. The wizened little host scurries about chopping this, shredding that, and showering everything with exotic herbs and spices. He rushes back and forth putting platters on the table in front of Luke, who watches the creature impatiently.

LUKE: Look, I'm sure it's delicious. I just don't understand why we can't see Yoda now.

CREATURE: Patience! For the Jedi it is time to eat as well. Eat, eat. Hot. Good food, hm? Good, hmm?

Moving with some difficulty in the cramped quarters, Luke sits down near the fire and serves himself from the pot. Tasting the unfamiliar concoction, he is pleasantly surprised.

LUKE: How far away is Yoda? Will it take us long to get there?

CREATURE: Not far. Yoda not far. Patience. Soon you will be with him. *(tasting food from the pot)* Rootleaf, I cook. Why wish you become Jedi? Hm?

LUKE: Mostly because of my father, I guess.

CREATURE: Ah, your father. Powerful Jedi was he, powerful Jedi, mmm.

LUKE: *(a little angry)* Oh, come on. How could you know my father? You don't even know who I am. *(fed up)* Oh, I don't know what I'm doing here. We're wasting our time.

The creature turns away from Luke and speaks to a third party.

CREATURE: *(irritated)* I cannot teach him. The boy has no patience.

Luke's head spins in the direction the creature faces. But there is no one there. The boy is bewildered, but it gradually dawns on him that the little creature is Yoda, the Jedi Master, and that he is speaking with Ben.

BEN'S VOICE: He will learn patience.

YODA: Hmmm. Much anger in him, like his father.

BEN'S VOICE: Was I any different when you taught me?

YODA: Hah. He is not ready.

LUKE: Yoda! I am ready. I . . . Ben! I can be a Jedi. Ben, tell him I'm ready.

Trying to see Ben, Luke starts to get up but hits his head on the low ceiling.

YODA: Ready, are you? What know you of ready? For eight hundred years have I trained Jedi. My own counsel will I keep on who is to be trained! A Jedi must have the deepest commitment, the most serious mind. *(to the invisible Ben, indicating Luke)* This one a long time have I watched. All his life has he looked away . . . to the future, to the horizon. Never his mind on where he was. Hmm? What he was doing. Hmph. Adventure. Heh! Excitement. Heh! A Jedi craves not these things. *(turning to Luke)* You are reckless!

Luke looks down. He knows it is true.

BEN'S VOICE: So was I, if you'll remember.

YODA: He is too old. Yes, too old to begin the training.

Luke thinks he detects a subtle softening in Yoda's voice.

LUKE: But I've learned so much.

Yoda turns his piercing gaze on Luke, as though the Jedi Master's huge eyes could somehow determine how much the boy has learned. After a long moment, the little Jedi turns toward where he alone sees Ben.

YODA: *(sighs)* Will he finish what he begins?

LUKE: I won't fail you—I'm not afraid.

YODA: *(turns slowly toward him)* Oh, you will be. You will be.

EXTERIOR: SPACE—STAR DESTROYERS—ASTEROID FIELD

The Imperial fleet around Vader's ship is surrounded by the asteroid storm. Asteroids big and small pelt the vast exteriors of the menacing ships. One of the smaller Imperial vessels is hit by a huge asteroid and explodes in a brilliant flash of light.

INTERIOR: ASTEROID CAVE—MILLENNIUM FALCON—COCKPIT

The cockpit is quiet and lit only by the indicator lights on the control panel. Princess Leia sits in the pilot's seat. She runs her hand across the control panel as she thinks of Han and the confusion he has created within her. Suddenly, something outside the cockpit window catches her eye. The reflection of the panel lights obscures her vision until a soft suctionlike cup attaches itself to the windscreen. Leia moves closer to see what it might be. Large, yellow eyes flash open and stare back at her. Startled, she jumps back into her seat, her heart pounding. There is a scurry of feet and a loud screech, and in an instant the eyes are gone. The young princess catches her breath, jumps out of her chair, and races from the cockpit.

INTERIOR: ASTEROID CAVE—MILLENNIUM FALCON—HOLD AREA

The lights go bright for a second, then go out again. Threepio and Chewbacca watch as Han finishes with some wires.

THREEPIO: Sir, if I may venture an opinion . . .

HAN: I'm not really interested in your opinion, Threepio.

Leia rushes into the cabin just as Han drops the final floor panel into place.

LEIA: *(out of breath)* There's something out there.

HAN: Where?

LEIA: Outside, in the cave.

As she speaks, there comes a sharp banging on the hull. Chewie looks up and barks anxiously.

THREEPIO: There it is. Listen! Listen!

HAN: I'm going out there.

LEIA: Are you crazy?!

HAN: I just got this bucket back together. I'm not going to let something tear it apart.

He and Chewie grab their breath masks off a rack and hurry out. Leia follows.

LEIA: Then I'm going with you.

THREEPIO: I think it might be better if I stay behind and guard the ship. *(hears another mysterious noise)* Oh, no.

EXTERIOR: ASTEROID CAVE—MILLENNIUM FALCON

It is very dark and dank inside the huge asteroid cave, too dark to see what is attacking the ship.

 Leia stamps her foot on the floor of the cave.

LEIA: This ground sure feels strange. It doesn't feel like rock at all.

Han kneels and studies the ground, then attempts to study the outline of the cave.

HAN: There's an awful lot of moisture in here.

LEIA: I don't know. I have a bad feeling about this.

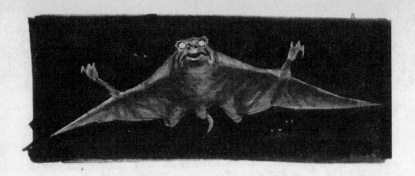

HAN: Yeah.

Chewie barks through his face mask, and points toward the ship's cockpit. A five-foot-long shape can be seen moving across the top of the Falcon. *The leathery creature lets out a screech as Han blasts it with a laser bolt.*

HAN: *(to Leia)* Watch out!

The black shape tumbles off the spaceship and onto the ground in front of the princess. Han bends down to investigate the dead creature.

HAN: Yeah, that's what I thought. Mynock. Chewie, check the rest of the ship, make sure there aren't any more attached. They're chewing on the power cables.

LEIA: Mynocks?

HAN: Go on inside. We'll clean them off if there are any more.

Just then, a swarm of the ugly creatures swoops through the air. Leia puts her arms over her head to protect herself as she runs toward the ship. Chewie shoos another mynock away with his blaster. Several of the batlike creatures flap their wings loudly against the cockpit window of the Falcon. *Inside, Threepio shudders at their presence.*

THREEPIO: Ohhh! Go away! Go away! Beastly thing. Shoo! Shoo!

Han looks around the strange, dripping cave.

HAN: Wait a minute . . .

He unholsters his blaster and fires at the far side of the huge cave. The cavern begins to shake and the ground starts to buckle.

 Chewie barks and moves for the ship, followed closely by Leia and Han. The large wings of the mynocks flap past them as they protect their faces and run up the platform.

INTERIOR: ASTEROID CAVE—MILLENNIUM FALCON—ENTRY AREA

As soon as Han and Leia are on board, Chewie closes the main hatch. The ship continues to shake and heave.

HAN: All right, Chewie, let's get out of here!

The Wookiee heads for the cockpit as Han, followed by Threepio, rushes to the hold area and checks the scopes on the control panel. Leia hurries after.

LEIA: The Empire is still out there. I don't think it's wise to . . .

Han rushes past her and heads for the cockpit.

HAN: *(interrupting)* No time to discuss this in committee.

And with that he is gone. The main engines of the Falcon *begin to whine. Leia races after him, bouncing around in the shaking ship.*

LEIA: *(angry)* I am not a committee!

INTERIOR: ASTEROID CAVE—MILLENNIUM FALCON—COCKPIT

Han is already in the pilot's seat pulling back on the throttle. The cave-quake has greatly diminished.

LEIA: You can't make the jump to light-speed in this asteroid field . . .

HAN: Sit down, sweetheart. We're taking off!

As the ship begins to move forward, Chewie barks. He notices something out the window ahead. Threepio sees it, too.

THREEPIO: Look!

HAN: I see it, I see it.

Suddenly, a row of jagged white stalagmites and stalactites can be seen surrounding the entrance. And as the Falcon *moves forward, the entrance to the cave grows ever smaller. Han pulls hard on the throttle, sending his ship surging forward.*

THREEPIO: We're doomed!

LEIA: The cave is collapsing.

HAN: This is no cave.

LEIA: What?

Leia's mouth drops open. She sees that the rocks of the cave entrance are not rocks at all, but giant teeth, quickly closing around the tiny ship. Chewie howls.

INTERIOR: SPACE SLUG MOUTH

The Millennium Falcon, *zooming through the monster's mouth, rolls on its side and barely makes it between two of the gigantic white teeth before the huge jaw slams closed.*

EXTERIOR: CAVE ENTRANCE—GIANT ASTEROID

The enormous space slug moves its head out of the cave as the Falcon flies out of its mouth. The monster tilts its head, watching the starship fly away.

EXTERIOR: MILLENNIUM FALCON—GIANT ASTEROID

The Falcon *races out of the asteroid crater and into the deadly rain of the asteroid storm.*

EXTERIOR: DAGOBAH—DAY

With Yoda strapped to his back, Luke climbs up one of the many thick vines that grow in the swamp. Panting heavily, he continues his course—climbing, flipping through the air, jumping over roots, and racing in and out of the heavy ground fog.

YODA: Run! Yes. A Jedi's strength flows from the Force. But beware of the dark side. Anger . . . fear . . . aggression. The dark side of the Force are they. Easily they flow, quick to join you in a fight. If once you start down the dark path, forever will it dominate your destiny, consume you it will, as it did Obi-Wan's apprentice.

LUKE: Vader. Is the dark side stronger?

YODA: No . . . no . . . no. Quicker, easier, more seductive.

LUKE: But how am I to know the good side from the bad?

YODA: You will know. When you are calm, at peace. Passive. A Jedi uses the Force for knowledge and defense, never for attack.

LUKE: But tell me why I can't . . .

YODA: *(interrupting)* No, no, there is no why. Nothing more will I teach you today. Clear your mind of questions. Mmm. Mmmmmm.

Artoo beeps in the distance as Luke lets Yoda down to the ground. Breathing heavily, he takes his shirt from a nearby tree branch and pulls it on.

He turns to see a huge, dead, black tree, its base surrounded by a few feet of water. Giant, twisted roots form a dark and sinister cave on one side. Luke stares at the tree, trembling.

LUKE: There's something not right here.

Yoda sits on a large root, poking his gimer stick into the dirt.

LUKE: I feel cold, death.

YODA: That place . . . is strong with the dark side of the Force. A domain of evil it is. In you must go.

LUKE: What's in there?

YODA: Only what you take with you.

Luke looks warily between the tree and Yoda. He starts to strap on his weapon belt.

YODA: Your weapons . . . you will not need them.

Luke gives the tree a long look, then shakes his head "no." Yoda shrugs. Luke reaches up to brush aside some hanging vines and enters the tree.

INTERIOR: DAGOBAH—TREE CAVE

Luke moves into the almost total darkness of the wet and slimy cave. The youth can barely make out the edge of the passage.

*Holding his lit saber before him, he sees a lizard crawling up
the side of the cave and a snake wrapped around the branches
of a tree. Luke draws a deep breath, then pushes deeper into
the cave.*

*The space widens around him, but he feels that rather than sees
it. His sword casts the only light as he peers into the darkness. It is
very quiet here.*

Then, a loud hiss! *Darth Vader appears across the blackness,
illuminated by his own just-ignited laser sword. Immediately,
he charges Luke, saber held high. He is upon the youth in
seconds, but Luke sidesteps perfectly and slashes at Vader with
his sword.*

*Vader is decapitated. His helmet-encased head flies from his
shoulders as his body disappears into the darkness. The metallic
banging of the helmet fills the cave as Vader's head spins and
bounces, smashes on the floor, and finally stops. For an instant it
rests on the floor, then it cracks vertically. The black helmet and
breath mask fall away to reveal . . . Luke's head.*

*Across the space, the standing Luke gasps at the sight, wide-eyed
in terror.*

The decapitated head fades away, as in a vision.

EXTERIOR: DAGOBAH—CAVE—DUSK

Meanwhile, Yoda sits on the root, calmly leaning on his gimer stick.

EXTERIOR: SPACE—VADER'S STAR DESTROYER

Vader's Imperial Star Destroyer moves through space, guarded by its convoy of TIE fighters.

INTERIOR: VADER'S STAR DESTROYER—BRIDGE—CONTROL DECK

Vader stands in the back control area of his ship's bridge with a motley group of men and creatures. Admiral Piett and two controllers stand at the front of the bridge and watch the group with scorn.

PIETT: Bounty hunters. We don't need that scum.

FIRST CONTROLLER: Yes, sir.

PIETT: Those Rebels won't escape us.

A second controller interrupts.

SECOND CONTROLLER: Sir, we have a priority signal from the Star Destroyer *Avenger*.

PIETT: Right.

The group standing before Vader is a bizarre array of galactic fortune hunters: There is Bossk, a slimy, tentacled monster with two huge, bloodshot eyes in a soft baggy face; Zuckuss and Dengar, two battle-scarred, mangy human types; IG-88, a battered, tarnished chrome war droid; and Boba Fett, a man in a weapon-covered armored space suit.

VADER: . . . there will be a substantial reward for the one who finds the *Millennium Falcon*. You are free to use any methods necessary, but I want them alive. No disintegrations.

BOBA FETT: As you wish.

At that moment, Admiral Piett approaches Vader in a rush of excitement.

PIETT: Lord Vader! My lord, we have them.

EXTERIOR: IMPERIAL STAR DESTROYER, AVENGER—
ASTEROID BELT

The Millennium Falcon *speeds through deep space, closely followed by a firing Imperial Star Destroyer. A large asteroid about the same size as the* Falcon *tumbles rapidly toward the starship. The tiny* Falcon *banks to avoid the giant asteroid as smaller rocks pelt its surface. Then the small craft roars under the asteroid, which explodes harmlessly on the hull of the vast Star Destroyer.*

INTERIOR: MILLENNIUM FALCON—COCKPIT

The ship shudders as flak explodes near the cockpit window. Threepio checks a tracking scope on the side control panel while Leia watches tensely out the window.

THREEPIO: Oh, thank goodness we're coming out of the asteroid field.

Chewie barks excitedly as the rain of asteroids begins to subside. A bolt from the Star Destroyer sets up a fiery explosion on the back side of the Falcon, *causing it to lurch to one side.*

EXTERIOR: MILLENNIUM FALCON—STAR DESTROYER, AVENGER— ASTEROID FIELD

The Falcon *is hit hard by another bolt from the Star Destroyer, which creates a huge explosion near the cockpit of the smaller ship. The* Falcon *tilts steeply, then rights itself.*

INTERIOR: MILLENNIUM FALCON—COCKPIT

Han corrects the angle of his ship.

HAN: Let's get out of here. Ready for light speed? One . . . two . . . three!

Han pulls back on the hyperspace throttle and—nothing happens. Flak bursts continue to rock the ship.

HAN: *(frantic)* It's not fair!

Chewie is very angry and starts to growl and bark at his friend and captain. Again, Han desperately pulls back on the throttle.

HAN: The transfer circuits are working. It's not my fault!

Chewie puts his head in his hands, whining.

LEIA: *(almost expecting it)* No light-speed?

HAN: It's not my fault.

THREEPIO: Sir, we just lost the main rear deflector shield. One more direct hit on the back quarter and we're done for.

Han pauses for a moment, makes a decision, and pulls back on a lever.

HAN: Turn her around.

Chewie barks in puzzlement.

HAN: I said turn her around! I'm going to put all power in the front shield.

LEIA: You're going to attack them?!

THREEPIO: Sir, the odds of surviving a direct assault on an Imperial Star Destroyer . . .

LEIA: Shut up!

EXTERIOR: SPACE—MILLENNIUM FALCON—ASTEROID FIELD

The Falcon *banks, making a steep, twisting turn. In the next moment it is racing toward the Star Destroyer, looking very small against the massive surface of the Imperial ship. As it moves across the surface of the Star Destroyer, the* Falcon *bobs and weaves to avoid the numerous flak bursts.*

INTERIOR: STAR DESTROYER, AVENGER—BRIDGE

The tiny Falcon *heads directly for the* Avenger's *bridge. The Imperials stationed there are stunned to see the small spaceship racing low across the hull, headed directly at the huge windows of the bridge area. Alarms go off everywhere. The Destroyer's commander, Captain Needa, can scarcely believe his eyes.*

NEEDA: They're moving to attack position. Shields up!

Needa and his men duck as the Falcon *nears the bridge window. At the last minute, the* Falcon *veers off and out of sight. All is quiet.*

NEEDA: Track them. They may come around for another pass.

TRACKING OFFICER: Captain Needa, the ship no longer appears on our scopes.

NEEDA: They can't have disappeared. No ship that small has a cloaking device.

TRACKING OFFICER: Well, there's no trace of them, sir.

COMMUNICATIONS OFFICER: Captain, Lord Vader demands an update on the pursuit.

NEEDA: *(drawing a breath)* Get a shuttle ready. I shall assume full responsibility for losing them, and apologize to Lord Vader. Meanwhile, continue to scan the area.

COMMUNICATIONS OFFICER: Yes, Captain Needa.

EXTERIOR: DAGOBAH—BOG—DAY

Luke's face is upside-down and showing enormous strain. He stands on his hands, with Yoda perched on his feet. Opposite Luke and Yoda are two rocks the size of bowling balls. Luke stares at the rocks and concentrates. One of the rocks lifts from the ground and floats up to rest on the other.

YODA: Use the Force. Yes . . .

Yoda taps Luke's leg. Quickly, Luke lifts one hand from the ground. His body wavers, but he maintains his balance. Artoo, standing nearby, is whistling and beeping frantically.

YODA: Now . . . the stone. Feel it.

Luke concentrates on trying to lift the top rock. It rises a few feet, shaking under the strain. But, distracted by Artoo's frantic beeping, Luke loses his balance and finally collapses. Yoda jumps clear.

YODA: Concentrate!

Annoyed at the disturbance, Luke looks over at Artoo, who is rocking urgently back and forth in front of him.

Artoo waddles closer to Luke, chirping wildly, then scoots over to the edge of the swamp. Catching on, Luke rushes to the water's edge. The X-wing fighter has sunk, and only the tip of its nose shows above the lake's surface.

LUKE: Oh, no. We'll never get it out now.

Yoda stamps his foot in irritation.

YODA: So certain are you. Always with you it cannot be done. Hear you nothing that I say?

Luke looks uncertainly out at the ship.

LUKE: Master, moving stones around is one thing. This is totally different.

YODA: No! No different! Only different in your mind. You must unlearn what you have learned.

LUKE: *(focusing, quietly)* All right, I'll give it a try.

YODA: No! Try not. *Do.* Or do not. There is no try.

Luke closes his eyes and concentrates on thinking the ship out.

Slowly, the X-wing's nose begins to rise above the water. It hovers for a moment and then slides back, disappearing once again.

LUKE: *(panting heavily)* I can't. It's too big.

YODA: Size matters not. Look at me. Judge me by my size, do you? Hm? Mmmm.

Luke shakes his head.

YODA: And well you should not. For my ally is the Force. And a powerful ally it is. Life creates it, makes it grow. Its energy surrounds

us and binds us. Luminous beings are we . . . *(Yoda pinches Luke's shoulder)* . . . not this crude matter. *(a sweeping gesture)* You must feel the Force around you. *(gesturing)* Here, between you . . . me . . . the tree . . . the rock . . . everywhere! Yes, even between this land and that ship!

LUKE: *(discouraged)* You want the impossible.

Quietly, Yoda turns toward the sunken X-wing fighter. With his eyes closed and his head bowed, he raises his arm and points at the ship.

Soon, the fighter rises above the water and moves forward as Artoo beeps in terror and scoots away.

The entire X-wing moves majestically, surely, toward the shore. Yoda stands on a tree root and guides the fighter carefully down toward the beach.

Luke stares in astonishment as the fighter settles gently onto the shore. He walks toward Yoda.

LUKE: I don't . . . I don't believe it.

YODA: That is why you fail.

Luke shakes his head, bewildered.

EXTERIOR: SPACE—IMPERIAL FLEET

The fleet around Vader's Star Destroyer now includes Needa's Star Destroyer, the Avenger.

INTERIOR: VADER'S STAR DESTROYER—BRIDGE

VADER: Apology accepted, Captain Needa.

Clutching desperately at his throat, Captain Needa slumps down, then falls over on his back, at the feet of Darth Vader. Two

stormtroopers pick up the lifeless body and carry it quickly away as Admiral Piett and two of his captains hurry up to the Dark Lord.

PIETT: Lord Vader, our ships have completed their scan of the area and found nothing. If the *Millennium Falcon* went into light-speed, it'll be on the other side of the galaxy by now.

VADER: Alert all commands. Calculate every possible destination along their last known trajectory.

PIETT: Yes, my lord. We'll find them.

VADER: Don't fail me again, Admiral.

Vader exits as the admiral turns to an aide, a little more uneasy than when he arrived.

PIETT: Alert all commands. Deploy the fleet.

EXTERIOR: SPACE—IMPERIAL FLEET

Vader's ship moves away, flanked by its fleet of smaller ships. The Avenger *glides off into space in the opposite direction. No one on that ship or on Vader's is aware that, clinging to the side of the* Avenger, *is the pirateship, the* Millennium Falcon.

INTERIOR: MILLENNIUM FALCON—COCKPIT

THREEPIO: Captain Solo, this time you have gone too far. *(Chewie growls)* No, I will not be quiet, Chewbacca. Why doesn't anyone listen to me?

HAN: *(to Chewie)* The fleet is beginning to break up. Go back and stand by the manual release for the landing claw.

Chewie barks, struggles from his seat, and climbs out of the cabin.

THREEPIO: I really don't see how that is going to help. Surrender is a perfectly acceptable alternative in extreme circumstances. The Empire may be gracious enough . . .

Leia reaches over and shuts off Threepio, midsentence.

HAN: Thank you.

LEIA: What did you have in mind for your next move?

HAN: Well, if they follow standard Imperial procedure, they'll dump their garbage before they go to light-speed, then we just float away.

LEIA: With the rest of the garbage. Then what?

HAN: Then we've got to find a safe port somewhere around here. Got any ideas?

LEIA: No. Where are we?

HAN: The Anoat system.

LEIA: Anoat system. There's not much there.

HAN: No. Well, wait. This is interesting. Lando.

He points to a computer mapscreen on the control panel. Leia slips out of her chair and moves next to the handsome pilot. Small light points representing several systems flash by on the computer screen.

LEIA: Lando system?

HAN: Lando's not a system, he's a man. Lando Calrissian. He's a card player, gambler, scoundrel. You'd like him.

LEIA: Thanks.

HAN: Bespin. It's pretty far, but I think we can make it.

LEIA: *(reading from the computer)* A mining colony?

HAN: Yeah, a Tibanna gas mine. Lando conned somebody out of it. We go back a long way, Lando and me.

LEIA: Can you trust him?

HAN: No. But he has no love for the Empire, I can tell you that.

Chewie barks over the intercom. Han quickly changes his readouts and stretches to look out the cockpit window.

HAN: *(into intercom)* Here we go, Chewie. Stand by. Detach!

Han leans back in his chair and gives Leia an inviting smile. She thinks for a moment, shakes her head; a grin creeps across her face and she gives him a quick kiss.

LEIA: You do have your moments. Not many, but you have them.

EXTERIOR: SPACE—IMPERIAL STAR DESTROYER

As the Avenger Star Destroyer moves slowly into space, the hatch on its underbelly opens, sending a trail of junk floating behind it. Hidden among the refuse, the Falcon tumbles away. In the next moment, the Avenger roars off into hyperspace. The Falcon's engines are ignited, and it races off into the distance. Amid the slowly drifting junk, Boba Fett's ship appears and moves after the Falcon.

EXTERIOR: DAGOBAH—BOG—CLEARING—DAY

In the clearing behind Yoda's house, Luke again stands upside-down, but his face shows less strain and more concentration than before. Yoda sits on the ground below the young warrior. On the other side of the clearing, two equipment cases slowly rise into the air. Nearby Artoo watches, humming to himself, when suddenly he, too, rises into the air. His little legs kick desperately and his head turns frantically, looking for help.

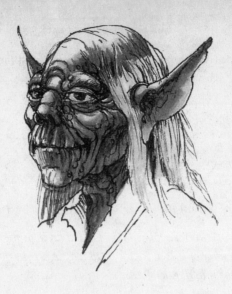

YODA: Concentrate . . . feel the Force flow. Yes. Good. Calm, yes. Through the Force, things you will see. Other places. The future . . . the past. Old friends long gone.

Luke suddenly becomes distressed.

LUKE: Han! Leia!

The two packing boxes and Artoo fall to the ground with a crash, then Luke himself tumbles over.

YODA: *(shaking his head)* Hmm. Control, control. You must learn control.

LUKE: I saw . . . I saw a city in the clouds.

YODA: Mmm. Friends you have there.

LUKE: They were in pain.

YODA: It is the future you see.

LUKE: Future? Will they die?

Yoda closes his eyes and lowers his head.

YODA: Difficult to see. Always in motion is the future.

LUKE: I've got to go to them.

YODA: Decide you must how to serve them best. If you leave now, help them you could. But you would destroy all for which they have fought and suffered.

Luke is stopped cold by Yoda's words. Gloom shrouds him as he nods his head sadly.

EXTERIOR: BESPIN SYSTEM—MILLENNIUM FALCON—DAWN

The powerful pirate starship blasts through space as it heads toward the soft pink planet of Bespin.

EXTERIOR: BESPIN SURFACE—MILLENNIUM FALCON

It is dawn on the gaseous planet. Huge billowing clouds form a canyon as the ship banks around them, headed toward the system's Cloud City.
 Suddenly, two twin-pod cloud cars appear and move toward the Falcon. *The cloud cars draw up alongside the starship.*

INTERIOR: MILLENNIUM FALCON—COCKPIT

One of the cloud cars opens fire on the Falcon, *its flak rocking the ship. Chewie barks his concern.*

HAN: *(into transmitter)* No, I don't have a landing permit. I'm trying to reach Lando Calrissian.

More flak bursts outside the cockpit window and rattles the ship's interior. Leia looks worried.

HAN: *(into transmitter)* Whoa! Wait a minute! Let me explain.

INTERCOM VOICE: You will not deviate from your present course.

THREEPIO: Rather touchy, aren't they?

LEIA: I thought you knew this person.

Chewie barks and growls at his boss.

HAN: *(to Chewie)* Well, that was a long time ago. I'm sure he's forgotten about that.

INTERCOM VOICE: Permission granted to land on Platform Three-two-seven.

HAN: *(into transmitter)* Thank you.

Angry, Han snaps off the intercom. Chewie looks at him and grunts. Han turns to the worried princess and her droid.

HAN: There's nothing to worry about. We go way back, Lando and me.

Leia doesn't look convinced.

LEIA: Who's worried?

EXTERIOR: CLOUD CITY—MILLENNIUM FALCON—CLOUD CARS

The clouds part to reveal a full view of the city as it bobs in and out of the cloud surface. The cloud cars and the Falcon *head for the gleaming white metropolis.*

EXTERIOR: CLOUD CITY—LANDING PLATFORM—MILLENNIUM FALCON

With the cloud cars still guarding it, the Falcon *lands on one of the Cloud City's platforms.*

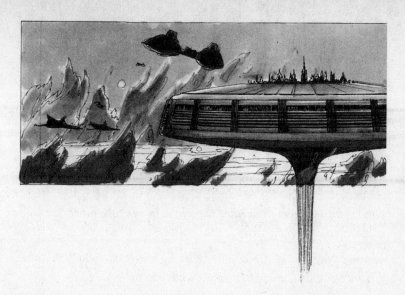

EXTERIOR: LANDING PLATFORM—DOOR OF MILLENNIUM FALCON

Han and Leia stand at the open door, armed. Behind them, Chewie, also armed, surveys the scene warily.

THREEPIO: Oh. No one to meet us.

LEIA: I don't like this.

HAN: Well, what would you like?

THREEPIO: Well, they *did* let us land.

HAN: Look, don't worry. Everything's going to be fine. Trust me.

INTERIOR: CLOUD CITY—CORRIDOR—DAY

Lando Calrissian, a suave, dashing black man in his thirties, leads a group of aides and some Cloud City guards rapidly toward the landing platform. The group, like the other citizens of the city, is a motley collection of aliens, droids, and humans of all descriptions. Lando has a grim expression on his face as he moves onto the landing platform.

EXTERIOR: LANDING PLATFORM—DOOR OF MILLENNIUM FALCON

HAN: See? My friend. *(to Chewie)* Keep your eyes open, okay?

Chewie growls as Han walks down the ramp. Lando and his men head across the bridge to meet the space pirate.

EXTERIOR: CLOUD CITY—LANDING PLATFORM

Lando stops ten feet from Han. The two men eye each other carefully. Lando shakes his head.

LANDO: Why, you slimy, double-crossing, no-good swindler! You've got a lot of guts coming here, after what you pulled.

Han points to himself innocently, mouthing, "Me?"
Lando moves threateningly toward Han. Suddenly, he throws his arms around his startled, long-lost friend and embraces him.

LANDO: *(laughs)* How you doing, you old pirate? So good to see you! I never thought I'd catch up with you again. Where you been?

The two old friends embrace, laughing and chuckling.

EXTERIOR: LANDING PLATFORM—DOOR OF MILLENNIUM FALCON

THREEPIO: Well, he seems very friendly.

LEIA: *(wary)* Yes . . . very friendly.

EXTERIOR: CLOUD CITY—LANDING PLATFORM

LANDO: What are you doing here?

HAN: *(gestures toward the Falcon)* Ahh . . . repairs. I thought you could help me out.

LANDO: *(in mock panic)* What have you done to my ship?

HAN: *Your* ship? Hey, remember, you lost her to me fair and square.

Chewie, Leia, and Threepio have made their way down the ramp.

LANDO: And how are you doing, Chewbacca? You still hanging around with this loser?

Chewie growls a reserved greeting. Lando suddenly notices the princess and smiles admiringly.

LANDO: Hello. What have we here? Welcome. I'm Lando Calrissian. I'm the administrator of this facility. And who might you be?

LEIA: Leia.

LANDO: Welcome, Leia.

Lando bows before Leia and kisses her hand.

HAN: All right, all right, you old smoothie.

Han takes Leia by the hand and steers her away from Lando.

THREEPIO: Hello, sir. I am See-Threepio, human-cyborg relations. My facilities are at your . . .

Before Threepio can finish his self-introduction, Lando has turned to follow Han and Leia, who are walking toward the city.

THREEPIO: Well, really!

Lando, his aide, Lobot, and Han lead the way across the bridge, followed by Threepio, Chewie, and Leia.

LANDO: What's wrong with the *Falcon*?

HAN: Hyperdrive.

LANDO: I'll get my people to work on it.

HAN: Good.

Lando turns to Leia.

LANDO: You know, that ship saved my life quite a few times. She's the fastest hunk of junk in the galaxy.

INTERIOR: CLOUD CITY—CORRIDOR

The group has crossed the narrow bridge and entered the city. They walk down the lovely Art Deco passageway, rounding several corners and passing many small plazas as they go. Threepio lags a bit behind.

HAN: How's the gas mine? Is it still paying off for you?

LANDO: Oh, not as well as I'd like. We're a small outpost and not very self-sufficient. And I've had supply problems of every kind. I've had labor difficulties, . . . *(catches Han grinning at him)* What's so funny?

HAN: You. Listen to you—you sound like a businessman, a responsible leader. Who'd have thought that, huh?

Lando is reflective. He looks at Han a moment.

LANDO: You know, seeing you sure brings back a few things.

HAN: Yeah.

LANDO: *(shakes his head)* Yeah, I'm responsible these days. It's the price you pay for being successful.

Han and Lando laugh together, and the group moves on through the corridor.

The lagging Threepio passes a Threepio-type silver droid who is coming out of a door.

THREEPIO: Oh! Nice to see a familiar face.

SECOND THREEPIO: *(mumbles)* E chu ta!

THREEPIO: How rude!

Threepio stops, watching the silver droid move away. Then he hears the muffled beeping and whistling of an R2 unit coming from within the room.

INTERIOR: CLOUD CITY—ANTEROOM

Curious, Threepio enters the room.

THREEPIO: That sounds like an R2 unit in there. I wonder if . . .

Threepio walks through the doorway to the main room. He looks in.

THREEPIO: Hello? How interesting. Oh, my.

MAN'S VOICE: *(from within)* Who are you?

THREEPIO: Oh, I'm terrible sorry. I . . . I didn't mean to intrude. No, no, please don't get up. No!

A laser bolt to Threepio's chest sends him flying in twenty directions. Smoldering mechanical arms and legs bounce off the walls as the door whooshes closed behind him.

INTERIOR: CLOUD CITY—CORRIDOR

Lando, Han, and Leia continue down the corridor unaware of Threepio's dreadful accident. Chewbacca glances around, sniffs the air, but shrugs his shoulders and follows the group.

EXTERIOR: DAGOBAH—BOG—DUSK

In the bright lights of the fighter, Luke loads a heavy case into the belly of the ship. Artoo sits on top of the X-wing, settling down into his cubbyhole. Yoda stands nearby on a log.

YODA: Luke! You must complete the training.

LUKE: I can't keep the vision out of my head. They're my friends. I've got to help them.

YODA: You must not go!

LUKE: But Han and Leia will die if I don't.

BEN'S VOICE: You don't know that.

Luke looks toward the voice in amazement. Ben has materialized as a real, slightly shimmering image near Yoda. The power of his presence stops Luke.

BEN: Even Yoda cannot see their fate.

LUKE: But I can help them! I feel the Force!

BEN: But you cannot control it. This is a dangerous time for you, when you will be tempted by the dark side of the Force.

YODA: Yes, yes. To Obi-Wan you listen. The cave. Remember your failure at the cave!

LUKE: But I've learned so much since then. Master Yoda, I promise to return and finish what I've begun. You have my word.

BEN: It is you and your abilities the Emperor wants. That is why your friends are made to suffer.

LUKE: And that is why I have to go.

BEN: Luke, I don't want to lose you to the Emperor the way I lost Vader.

LUKE: You won't.

YODA: Stopped they must be. On this all depends. Only a fully trained Jedi Knight with the Force as his ally will conquer Vader and his Emperor. If you end your training now, if you choose the quick and easy path, as Vader did, you will become an agent of evil.

BEN: Patience.

LUKE: And sacrifice Han and Leia?

YODA: If you honor what they fight for . . . yes!

Luke is in great anguish. He struggles with the dilemma, a battle raging in his mind.

BEN: If you choose to face Vader, you will do it alone. I cannot interfere.

LUKE: I understand. *(he moves to his X-wing)* Artoo, fire up the converters.

Artoo whistles a happy reply.

BEN: Luke, don't give in to hate—that leads to the dark side.

Luke nods and climbs into his ship.

YODA: Strong is Vader. Mind what you have learned. Save you it can.

LUKE: I will. And I'll return. I promise.

Artoo closes the cockpit. Ben and Yoda stand watching as the roar of the engines and the wind engulfs them.

YODA: *(sighs)* Told you, I did. Reckless is he. Now matters are worse.

BEN: That boy is our last hope.

YODA: *(looks up)* No. There is another.

EXTERIOR: SPACE—PLANET DAGOBAH

Luke's tiny X-wing rockets away from the green planet of Dagobah and off into space.

INTERIOR: CLOUD CITY—LIVING QUARTERS—DAY

Within the quarters assigned her on Cloud City, Leia paces in agitation. She has changed from her cold-weather pants and jacket to a lovely dress. Her hair is down, tied back with ribbons. She moves from a large, open window and turns to see Han entering through the doorway.

HAN: The ship is almost finished. Two or three more things and we're in great shape.

LEIA: The sooner the better. Something's wrong here. No one has seen or knows anything about Threepio. He's been gone too long to have gotten lost.

Han takes Leia by the shoulders and gently kisses her forehead.

HAN: Relax. I'll talk to Lando and see what I can find out.

LEIA: I don't trust Lando.

HAN: Well, I don't trust him, either. But he is my friend. Besides, we'll soon be gone.

LEIA: And then you're as good as gone, aren't you?

Not speaking, Han considers her words and gazes at her troubled face.

INTERIOR: CLOUD CITY—JUNK ROOM

The room is piled high with broken and discarded machine parts. Four Ugnaughts, small hoglike creatures, separate the junk and throw some pieces onto a conveyor belt which moves briskly toward a pit of molten metal. Pieces of Threepio's golden body move down the belt. Chewie enters the room and spots an Ugnaught picking up and inspecting Threepio's head. The Wookiee barks a command, startling the Ugnaught, then reaches to grab the head. But the Ugnaught tosses it away from him to another Ugnaught. This game of keep-away goes on until Threepio's head falls from their grip and bounces with a clang onto the ground.

INTERIOR: CLOUD CITY—LIVING QUARTERS—DAY

The door zaps open. Chewbacca walks in, carrying a packing case of Threepio, arms and legs hanging over the edges.

LEIA: What happened?

Chewie sets the case on a table, grunting and groaning an explanation.

HAN: Where? Found him in a junk pile?

LEIA: Oh, what a mess. Chewie, do you think you can repair him?

The giant Wookiee studies the array of robot parts. He looks at the princess and shrugs sadly.

HAN: Lando's got people who can fix him.

LEIA: No, thanks.

There is a buzz and the door slides open, revealing Lando.

LANDO: I'm sorry. Am I interrupting anything?

LEIA: Not really.

LANDO: You look absolutely beautiful. You truly belong here with us among the clouds.

LEIA: *(coolly)* Thank you.

LANDO: Will you join me for a little refreshment?

Han looks at Lando suspiciously, but Chewie barks at the mention of food and licks his lips.

LANDO: Everyone's invited, of course.

Leia takes Lando's proffered arm, and the group turns to go. Lando spots Threepio's remains.

LANDO: Having trouble with your droid?

Han and Leia exchange a quick glance.

HAN: No. No problem. Why?

Han and Leia move arm in arm through the door, followed by Lando and Chewie. The door slides closed behind them.

INTERIOR: CLOUD CITY—CORRIDOR—DAY

Leia walks between Han and Lando as Chewie follows a short distance behind. Long shafts of light pour across the corridor between tall, pure-white columns.

LANDO: So you see, since we're a small operation, we don't fall into the . . . uh . . . jurisdiction of the Empire.

LEIA: So you're part of the mining guild then?

LANDO: No, not actually. Our operation is small enough not to be noticed . . . which is advantageous for everybody since our customers are anxious to avoid attracting attention to themselves.

The group walks into another corridor and heads for a huge doorway at the far end.

HAN: Aren't you afraid the Empire's going to find out about this little operation and shut you down?

LANDO: That's always been a danger looming like a shadow over everything we've built here. But things have developed that will insure security. I've just made a deal that will keep the Empire out of here forever.

INTERIOR: CLOUD CITY—DINING ROOM

The mighty doors to the dining room slide open and the group enters. At the far end of a huge banquet table sits Darth Vader. Standing at his side and slightly behind him is Boba Fett, the bounty hunter.
Faster than the wink of an eye, Han draws his blaster and pops off a couple of shots directly at Vader. The Dark Lord quickly raises his hand, deflecting the bolts into one of the side walls, where they explode harmlessly. Just as quickly, Han's weapon zips into Vader's hand. The evil presence calmly places the gun on the table in front of him.

VADER: We would be honored if you would join us.

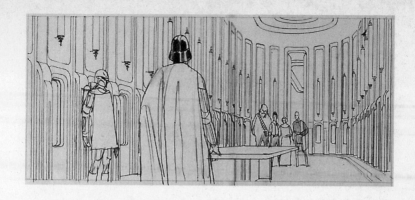

Han gives Lando a mean look.

LANDO: I had no choice. They arrived right before you did. I'm sorry.

HAN: I'm sorry, too.

EXTERIOR: LUKE'S X-WING—BESPIN SYSTEM

Luke's X-wing races through thick clouds toward Cloud City.

INTERIOR: LUKE'S X-WING—COCKPIT

Luke is grim-faced as he pilots his course toward Bespin's shining city. Artoo's beeps and whistles are transmitted onto the scope.

LUKE: *(into comlink)* No, Threepio's with them.

Artoo whistles another worried inquiry.

LUKE: *(into comlink)* Just hang on. We're almost there.

INTERIOR: CLOUD CITY—LARGE CELL

Chewbacca is in a Cloud City prison cell. The stark room is flooded with hot light. To add to Chewie's misery, a high-pitched whistle screeches loudly. Chewie is going mad. He hits the wall with his giant fists as he paces back and forth across the cell floor. The upper lights

go off abruptly. The prisoner rubs his eyes and moves to a wall, where he listens for a moment. Then, moaning to himself, he moves to a platform where the disassembled pieces of Threepio lie. He picks up the golden droid's head and meditates on it for a moment, barking a few philosophical remarks. Chewie sticks the robot's head on its torso and starts adjusting wires and circuits. Suddenly, the lights in Threepio's eyes spark to life as Chewie touches two connectors together. Threepio immediately begins to speak, but his voice is so slow and so low as to be nearly unintelligible.

THREEPIO: Mmm. Oh, my. Uh, I, uh—Take this off! I, uh, don't mean to intrude here. I, don't, no, no, no . . . Please don't get up. No!

Chewie looks at Threepio in bewilderment, then scratches his furry head. He gets an idea and adjusts some connections, whereupon. Threepio immediately begins speaking normally.

THREEPIO: Stormtroopers? Here? We're in danger. I must tell the others. Oh, no! I've been shot!

INTERIOR: CLOUD CITY—PRISON ENTRY AREA

Darth Vader strides through the room as two stormtroopers prepare an elaborate torture mechanism. Han is strapped to a rack which tilts forward onto the torture device. Vader activates the mechanism, creating two bursts of sparks, one of which strikes Han in the face.

The door opens, and Vader leaves the torture room just as Han screams a sharp, piercing cry of agony. Darth Vader moves to the holding chamber, where Lando and Boba Fett await him.

INTERIOR: CLOUD CITY—HOLDING CHAMBER

LANDO: Lord Vader.

VADER: *(to Fett)* You may take Captain Solo to Jabba the Hutt after I have Skywalker.

Han's screams filter through the torture room door.

BOBA FETT: He's no good to me dead.

VADER: He will not be permanently damaged.

LANDO: Lord Vader, what about Leia and the Wookiee?

VADER: They must never again leave this city.

LANDO: That was never a condition of our agreement, nor was giving Han to this bounty hunter!

VADER: Perhaps you think you're being treated unfairly.

LANDO: No.

VADER: Good. It would be unfortunate if I had to leave a garrison here.

Vader turns and sweeps into the elevator with Boba Fett. Lando walks swiftly down another corridor, muttering to himself.

LANDO: This deal's getting worse all the time.

INTERIOR: CLOUD CITY—LARGE CELL

Chewie now has a little more of Threepio back together. One arm is connected, but the legs are yet to be attached. There is one small problem, however: It seems the Wookiee has managed to put the droid's head on backward.

THREEPIO: Oh, yes, that's very good. I like that. Oh! Something's not right because now I can't see. Wait. Wait! Oh, my! What have you done? I'm backwards, you stupid furball. Only an overgrown mop-head like you would be stupid enough . . .

Threepio is cut off in midsentence as Chewie angrily deactivates a circuit and the droid shuts down. The Wookiee smells something and sits up. The door to the chamber slides open and a ragged Han Solo is shoved into the room by two stormtroopers. Barking his concern,

the huge Wookiee gives Han a big hug. Han is very pale, with dark circles under his eyes.

HAN: I feel terrible.

Chewie helps Han to a platform and then turns as the door slides open revealing Leia. She, too, looks a little the worse for wear. The troopers push her into the cell, and the door slides closed. She moves to Han, who is lying on the platform, and kneels next to him, gently stroking his head.

LEIA: Why are they doing this?

HAN: They never even asked me any questions.

The cell door slides open. Lando and two of his guards enter.

LEIA: Lando.

HAN: Get out of here, Lando!

LANDO: Shut up and listen! Vader has agreed to turn Leia and Chewie over to me.

HAN: Over to you?

LANDO: They'll have to stay here, but at least they'll be safe.

LEIA: What about Han?

LANDO: Vader's giving him to the bounty hunter.

LEIA: Vader wants us all dead.

LANDO: He doesn't want you at all. He's after somebody called Skywalker.

HAN: Luke?

LANDO: Lord Vader has set a trap for him.

Leia's mind is racing.

LEIA: And we're the bait.

LANDO: Well, he's on his way.

Han's rage peaks.

HAN: Perfect. You fixed us all pretty good, didn't you? *(spits it out)* My friend!

Han hauls off and punches Lando. The two friends are instantly engaged in a frantic close-quarters fight. The guards hit Han with their rifle butts and he flies across the room. Chewie growls and starts for the guards. They point their laser weapons at the giant Wookiee, but Lando stops them.

LANDO: Stop! I've done all I can. I'm sorry I couldn't do better, but I have my own problems.

HAN: Yeah, you're a real hero.

Lando and the guards leave. Han wipes the blood from his chin as Leia and Chewie help him sit up.

LEIA: *(dabs at his wound)* You certainly have a way with people.

INTERIOR: CLOUD CITY—CARBON-FREEZING CHAMBER

Four armor-suited stormtroopers stand at the ready in the large chamber, which is filled with pipes and chemical tanks. In the middle of the room is a round pit housing a hydraulic platform. Darth Vader and Lando stand near the platform.

VADER: This facility is crude, but it should be adequate to freeze Skywalker for his journey to the Emperor.

An Imperial soldier appears.

IMPERIAL SOLDIER: Lord Vader, ship approaching. X-wing class.

VADER: Good. Monitor Skywalker and allow him to land.

The soldier bows and leaves the chamber.

LANDO: Lord Vader, we only use this facility for carbon freezing. If you put him in there, it might kill him.

VADER: I do not want the Emperor's prize damaged. We will test it . . . on Captain Solo.

Lando's face registers dismay.

EXTERIOR: SPACE—BESPIN SYSTEM—LUKE'S X-WING

Luke's X-wing moves through the clouds as it nears the city.

INTERIOR: LUKE'S X-WING—COCKPIT

Encountering no city guards, Luke scans his display panels with concern.

INTERIOR: CLOUD CITY—CARBON-FREEZING CHAMBER

There is great activity on the carbon-freezing platform. Six Ugnaughts frantically prepare the chamber for use. A special coffinlike container is put in place. With Boba Fett in the lead, a squad of six stormtroopers brings in Han, Leia, and Chewie. Strapped to Chewie's back, with only his head, torso, and one arm assembled, is Threepio. Threepio's head faces the opposite direction from Chewie's and the droid is constantly twisting around in a vain effort to see what is happening. His one attached arm is animate and expressive, intermittently pointing, gesturing, and covering his eyes. The remaining pieces of his body are randomly bundled to the Wookiee's back so that his legs and other arm stick out at odd angles from the pack.

THREEPIO: If only you had attached my legs, I wouldn't be in this ridiculous position. Now, remember, Chewbacca, you have a responsibility to me, so don't do anything foolish.

HAN: *(to Lando)* What's going on . . . buddy?

LANDO: You're being put into carbon freeze.

Boba Fett moves away from the group to Darth Vader.

BOBA FETT: What if he doesn't survive? He's worth a lot to me.

VADER: The Empire will compensate you if he dies. Put him in!

Realizing what is about to happen, Chewie lets out a wild howl and attacks the stormtroopers surrounding Han. Within seconds, other Imperial reinforcements join the scuffle, clubbing the giant Wookiee with their laser weapons. From the instant of Chewie's first move, Threepio begins to scream in panic while he tries to protect himself with his one arm.

THREEPIO: Oh, no! No, no, no! Stop, Chewbacca, stop . . . !

The stormtroopers are about to bash Chewie in the face.

HAN: Stop, Chewie, stop! Do you hear me? Stop!

THREEPIO: Yes, stop, please! I'm not ready to die.

Han breaks away from his captors. Vader nods to the guards to let him go and the pirate breaks up the fight.

HAN: Chewie! Chewie, this won't help me. Hey!

Han gives the Wookiee a stern look.

HAN: Save your strength. There'll be another time. The princess—you have to take care of her. You hear me?

Han winks at the Wookiee, who wails a doleful farewell.

In a flash the guards have slipped binders on Chewbacca, who is too distraught to protest. Han turns to Princess Leia. They look sorrowfully at one another, then Han moves toward her and gives her a final, passionate kiss.

LEIA: I love you!

HAN: I know.

Tears roll down Leia's face as she watches the dashing pirate walk to the hydraulic platform. Han looks one final time at his friends—and then, suddenly, the platform drops. Chewie howls. Leia turns away in agony. Lando winces in sorrow; it makes a life-changing impression on him.

Instantly, fiery liquid begins to pour down in a shower of sparks and fluid as great as any steel furnace. Holding Leia, Chewie half-turns away from the sight, giving Threepio a view of the procedure.

THREEPIO: What . . . what's going on? Turn round, Chewbacca, I can't see. Oh . . . they've encased him in carbonite. He should be quite well-protected—if he survives the freezing process, that is.

Chewie is in no mood for technical discussions; he gives the droid an angry glance and bark.

A huge mechanical tong lifts the steaming metal-encased space pirate out of the vat and stands him on the platform. Some Ugnaughts rush over and push the block over onto the platform. They slide the coffinlike structure to the block and lift the metal block, placing it inside. They then attach an electronic box onto the structure and step away.

Lando kneels and adjusts some knobs, measuring the heat. He shakes his head in relief.

VADER: Well, Calrissian, did he survive?

LANDO: Yes, he's alive. And in perfect hibernation.

Vader turns to Boba Fett.

VADER: He's all yours, bounty hunter. Reset the chamber for Skywalker.

IMPERIAL OFFICER: Skywalker has just landed, my lord.

VADER: Good. See to it that he finds his way in here. Calrissian, take the princess and the Wookiee to my ship.

LANDO: You said they'd be left in the city under my supervision.

VADER: I am altering the deal. Pray I don't alter it any further.

Lando's hand instinctively goes to his throat as he turns to Leia, Chewie, and Threepio.

INTERIOR: CLOUD CITY—CORRIDOR—DAY

As Luke and Artoo move carefully down a deserted corridor, they hear a group of people coming down a side hallway. Artoo lets out an excited series of beeps and whistles. Luke glares at the tiny droid, who stops in his tracks with a feeble squeak.

Boba Fett enters from a side hallway followed by two guards pushing the floating, encased body of Han Solo. Two stormtroopers, who follow, immediately spot Luke and open fire on him. The youth draws his weapon and blasts the two troopers before they can get off a second shot. The two guards whisk Han into another hallway as Fett lowers his arm and fires a deadly laser at Luke, which explodes to one side and tears up a huge chunk of wall.

Luke rushes to a side hallway, but by the time he reaches it, Fett, Han, and the guards are gone. A thick metal door blocks the passage. Luke turns to see Leia, Chewie, Threepio, and Lando being herded down a second hallway by several other stormtroopers. Leia turns just in time to see Luke.

LEIA: Luke! Luke, don't—it's a trap! It's a trap!

Before she can finish, she is pulled through a doorway and disappears from sight. Luke races after the group, leaving little Artoo trailing behind.

INTERIOR: CLOUD CITY—ANTEROOM

Luke runs into an anteroom and stops to get his bearings. Leia and the others are nowhere to be seen. Behind Luke, Artoo scoots down the corridor toward the anteroom when suddenly a giant metal door comes slamming down, cutting off Luke's exit. Several more doors clang shut, echoing through the chamber.

INTERIOR: CLOUD CITY—HALLWAY LEADING TO ANTEROOM

Artoo stands with his nose pressed up against the giant metal door. He whistles a long sigh of relief and, a little dazed, wanders off in the other direction.

INTERIOR: CLOUD CITY—CARBON-FREEZING CHAMBER— ANTEROOM

Luke cautiously walks forward among hissing pipes and steam. Seeing an opening above him, he stops to look up. As he does, the platform he stands on begins to move.

INTERIOR: CLOUD CITY—CARBON-FREEZING CHAMBER

Luke rises into the chamber, borne by the platform. The room is deathly quiet. Very little steam escapes the pipes and no one else seems to be in the large room. Warily, Luke walks toward the stairway.

Steam begins to build up in the chamber. Looking up through the steam, Luke sees a dark figure standing on a walkway above him. Luke holsters his gun and moves up the stairs to face Vader. He feels confident, eager to engage his enemy.

VADER: The Force is with you, young Skywalker. But you are not a Jedi yet.

Luke ignites his sword in answer. In an instant, Vader's own sword is lit. Luke lunges, but Vader repels the blow. Again Luke attacks, and the swords of the two combatants clash in battle.

INTERIOR: CLOUD CITY—CORRIDOR

Leia, Lando, and Chewie, with Threepio on his back, march along, guarded by six stormtroopers. The group reaches an intersection where Lobot and a dozen of Lando's guards stand at attention.

The guards immediately aim their weapons at the startled stormtroopers. Taking the stormtroopers' weapons from them, Lobot hands one to Leia and one to Lando.

LANDO: Well done. Hold them in the security tower—and keep it quiet. Move.

As Lando's guards quickly march the stormtroopers away, Lando begins to undo Chewie's binding.

LEIA: What do you think you're doing?

LANDO: We're getting out of here.

THREEPIO: I knew all along it had to be a mistake.

Chewie turns on Lando and starts to choke him.

LEIA: Do you think that after what you did to Han we're going to trust you?

Lando tries to free himself from Chewie.

LANDO: *(choking)* I had no choice . . .

Chewie barks ferociously.

THREEPIO: *(to Chewie)* What are you doing? Trust him, trust him!

LEIA: Oh, so we understand, don't we, Chewie? He had no choice.

LANDO: I'm just trying to help . . .

LEIA: We don't need any of your help.

LANDO: *(choking)* H-a-a-a . . .

LEIA: What?

THREEPIO: It sounds like Han.

LANDO: There's still a chance to save Han . . . I mean, at the East Platform . . .

LEIA: Chewie.

Chewie finally releases Lando, who fights to get his breath back.

THREEPIO: *(to Lando)* I'm terribly sorry about all this. After all, he's only a Wookiee.

EXTERIOR: CLOUD CITY—EAST LANDING PLATFORM—BOBA FETT'S SHIP

The two guards slide Han's encased body into an opening in the side of the bounty hunter's ship. Boba Fett climbs aboard on a ladder next to the side opening.

BOBA FETT: Put Captain Solo in the cargo hold.

And with that, the door slams shut.

INTERIOR: CLOUD CITY—CORRIDOR

Lando, Leia, and Chewie run down a Cloud City corridor when suddenly they spot Artoo who rushes toward them, beeping wildly.

THREEPIO: Artoo! Artoo! Where have you been?

Chewie turns around to see the stubby droid, causing Threepio to be spun out of sight of his friend.

THREEPIO: Turn around, you woolly . . . ! *(to Artoo)* Hurry, hurry! We're trying to save Han from the bounty hunter!

Whistling frantically to Threepio, Artoo scoots along with the racing group.

THREEPIO: Well, at least you're still in one piece! Look what happened to me!

EXTERIOR: EAST LANDING PLATFORM—SIDE BAY

An elevator door slides open and Lando, Leia, and Chewbacca race for a large bay overlooking the East Landing Platform.

Just as they arrive, Boba Fett's ship takes off against the cloudy sunset sky.

In wild anguish, Chewie howls and starts firing at the ship.

THREEPIO: Oh, no! Chewie, they're behind you!

A laser bolt explodes near the princess. Everyone turns to see what Threepio has already spotted coming from the other direction: a squad of stormtroopers running toward them. Artoo peeks out from the elevator.

Leia and Chewbacca start firing at the troopers as Lando makes a break for the elevator. Laser bolts continue to explode around the princess and the Wookiee, but they refuse to budge. Lando sticks his head out of the elevator and motions for the pair to run, but they barely notice. They seem possessed, transported, as all the frustration of captivity and anger of loss pour out through their death-dealing weapons.

But after a few moments, they begin to move through the rain of laser fire toward the elevator. Once they are inside, the door slams shut and the stormtroopers race forward.

INTERIOR: CLOUD CITY—CARBON-FREEZING CHAMBER

Luke and Vader are locked in combat on the platform overlooking the chamber. Their swords clash, the platform sways. Luke aggressively drives Vader back, forcing Vader to use defensive tactics.

VADER: You have learned much, young one.

LUKE: You'll find I'm full of surprises.

Vader makes two quick moves, hooking Luke's sword out of his hands and sending it flying. Another lightning move at Luke's feet forces the youth to jump back to protect himself. Losing his balance, Luke rolls down the stairs to the circular carbon-freezing platform. There he sprawls on the floor, surprised and shaken. Just in time he looks up to see Vader, like a giant black bird, flying right at him. Luke rolls away as Vader lands. Crouching, Luke keeps his gaze steadily on his enemy.

VADER: Your destiny lies with me, Skywalker. Obi-Wan knew this to be true.

LUKE: No!

Behind Luke the hydraulic elevator cover has opened noiselessly. All the while, Luke slowly, cautiously moves back, away from the Dark Lord.

Suddenly, Vader attacks so forcefully that Luke loses his balance and falls back into the opening. There is a rumble, and in an instant freezing steam rises to obscure Vader's vision. Vader turns aside and deactivates his sword.

VADER: All too easy. Perhaps you are not as strong as the Emperor thought.

Through the steam behind Vader something blurs upward. Liquid metal begins to pour into the pit.

Vader turns around—and then looks up. He sees Luke, who has leaped fifteen feet straight up and who now hangs from some hoses on the carbonite outlet.

VADER: Impressive . . . most impressive.

Luke jumps down to the platform where he is separated from Vader by the steaming carbonite pit. He raises his hand. His sword, which had fallen on another part of the platform, swiftly jumps into his outstretched hand and is instantly ignited. Vader immediately lights his sword as well.

VADER: Obi-Wan has taught you well. You have controlled your fear . . . now release your anger.

Luke is more cautious, controlling his anger. He begins to retreat as Vader goads him on. As Luke takes a defensive position, he realizes he has been foolhardy. A quick sword exchange and Luke forces Vader back. Another exchange and Vader retreats. Luke presses forward.

VADER: Only your hatred can destroy me.

Breathing hard, Luke jumps in the air, turning a somersault over Vader. He lands on the floor and slashes at Vader as the room continues to fill up with steam.

Vader retreats before Luke's skillful sword. Vader blocks the sword, but loses his balance and falls into the outer rim of pipes. The energy Luke has used to stop Vader has brought him to the point of collapse. Luke moves to the edge and looks down, but sees no sign of Vader. He then deactivates his sword, hooks it on his belt, and lowers himself into the pit.

INTERIOR: CLOUD CITY—TUNNEL AND REACTOR CONTROL ROOM

Moving through a tunnel-like entrance, Luke cautiously approaches the reactor room. He ignites his sword and moves into the room and toward a large window as Vader enters.

Luke raises his sword and moves forward to attack.

Behind Luke a large piece of machinery detaches itself from the wall and comes smashing forward toward his back. Luke turns and cuts it in half just as another machine comes hurtling at him. Using the Force, Luke manages to deflect it and sends it flying as if it had hit an invisible shield. A large pipe detaches and comes flying at Luke. He deflects it. Sparking wires pull out of the walls and begin to whip at the youth. Small tools and equipment come flying at him. Bombarded from all sides, Luke does his best to deflect everything, but soon he is bloodied and bruised. Finally, one machine glances off him and goes flying out the large window. A fierce wind blows into the room,

whipping everything about and creating a horrendous noise. In the center of the room, unmoving, stands the dark, rocklike figure of Vader. A piece of machinery hits Luke and he is knocked out the window.

INTERIOR: GANTRY—OUTSIDE CONTROL ROOM—REACTOR SHAFT

Luke falls onto the gantry, rolls, and hangs over the edge, holding his deactivated sword in hand. He puts the sword on his belt and begins to scramble up.

INTERIOR: CLOUD CITY—CORRIDOR LEADING TO LANDING PLATFORM

Leia, Lando, Chewie, and the droids come round a corner and head for the door to the landing platform. They glimpse the Millennium Falcon *for a moment before the door slams shut. The group ducks into an alcove as stormtroopers arrive at the end of the corridor. The troopers send a rain of laser bolts at the group. Chewie returns their fire as Lando punches desperately at the door's control panel.*

LANDO: The security code has been changed!

THREEPIO: Artoo, you can tell the computer to override the security system.

Threepio points to a computer socket on the control panel. Artoo beeps and scoots toward it. Lando meanwhile has connected up to the panel's intercom.

LANDO: Attention! This is Lando Calrissian. The Empire has taken control of the city. I advise everyone to leave before more Imperial troops arrive.

Artoo takes off a connector cover and sticks his computer arm into the socket. Suddenly, a short beep turns into a wild scream. Artoo's circuits light up, his head spins wildly, and smoke begins to seep out underneath him. Quickly, Chewie pulls him away.

LANDO: This way.

Lando, Leia, Artoo, and Chewie flee down the corridor. As he scoots along with them, Artoo sends some angry beeps Threepio's way.

THREEPIO: Don't blame me. I'm an interpreter. I'm not supposed to know a power socket from a computer terminal.

INTERIOR: CLOUD CITY—CORRIDOR

In a panic, Cloud City residents are trying to get out of the city. Some carry boxes, others packages. They run, then change direction. Some are shooting at stormtroopers, others simply try to hide.

Other stormtroopers pursue Lando, Leia, and Chewie who are firing back at them. Artoo works on another door to the landing platform while Threepio berates him for his seeming ineptitude.

THREEPIO: What are you talking about? We're not interested in the hyperdrive on the *Millennium Falcon.* It's fixed! Just open the door, you stupid lump.

Chewie, Leia, and Lando retreat along the corridor. A triumphant beep from Artoo—and the door snaps open.

THREEPIO: *(to Artoo)* I never doubted you for a second. Wonderful!

Artoo lays down a cloud of fog, obscuring everything, as the group dashes outside.

EXTERIOR: LANDING PLATFORM—CLOUD CITY—DUSK

They race for the Millennium Falcon *as a battalion of stormtroopers reaches the main door. Lando and Leia hold off the troops as the droids get on board with Chewie. As Chewie bounds to the ship with Threepio on his back, Threepio hits his head on the top of the ramp.*

THREEPIO: Ouch! Oh! Ah! That hurt. Bend down, you thoughtless . . . Ow!

Chewie starts up the ship. The giant engines begin to whine as Lando and Leia race up the ramp under a hail of laser fire.

LANDO: Leia! Go!

INTERIOR: MILLENNIUM FALCON—CORRIDOR

Artoo drags the partially assembled Threepio down the corridor of the Falcon.

THREEPIO: I thought that hairy beast would be the end of me. Of course, I've looked better.

Artoo beeps understandingly.

INTERIOR: MILLENNIUM FALCON—COCKPIT

Chewie works the controls as Leia sits in Han's seat and Lando watches over their shoulders. As Chewie pulls back on the throttle, the ship begins to move.

EXTERIOR: CLOUD CITY—LANDING PLATFORM—DUSK

The Millennium Falcon *lifts gracefully into the twilight sky and roars away from the city. Troops fire after it and TIE fighters take off in pursuit.*

INTERIOR: GANTRY—OUTSIDE CONTROL ROOM—REACTOR SHAFT

Luke moves along the railing and up to the control room. Vader lunges at him and Luke immediately raises his lit sword to meet Vader's. Sparks fly as they duel, Vader gradually forcing Luke backward toward the gantry.

VADER: You are beaten. It is useless to resist. Don't let yourself be destroyed as Obi-Wan did.

Luke answers by rolling sideways and thrusting his sword at Vader so viciously that he nicks Vader on the shoulder. The black armor sparks and smokes and Vader seems to be hurt, but immediately recovers.

Luke backs off along the narrow end of the gantry as Vader comes at him, slashing at the young Jedi with his sword. Luke makes a quick move around the instrument complex attached to the end of the gantry. Vader's sword comes slashing down, cutting the complex loose; it begins to fall, then is caught by the rising wind and blown upward.

Luke glances at the instrument complex floating away. At that instant, Vader's sword comes down across Luke's right forearm, cutting off his hand and sending his sword flying. In great pain, Luke squeezes his forearm under his left armpit and moves back along the gantry to its extreme end. Vader follows. The wind subsides. Luke holds on. There is nowhere else to go.

VADER: There is no escape. Don't make me destroy you. You do not yet realize your importance. You have only begun to discover your power. Join me and I will complete your training. With our combined strength, we can end this destructive conflict and bring order to the galaxy.

LUKE: I'll never join you!

VADER: If you only knew the power of the dark side. Obi-Wan never told you what happened to your father.

LUKE: He told me enough! He told me *you* killed him.

VADER: No. *I* am your father.

Shocked, Luke looks at Vader in utter disbelief.

LUKE: No. No. That's not true! That's impossible!

VADER: Search your feelings. You know it to be true.

LUKE: No! No! No!

VADER: Luke. You can destroy the Emperor. He has foreseen this. It is your destiny. Join me, and together we can rule the galaxy as father and son. Come with me. It is the only way.

Vader puts away his sword and holds his hand out to Luke.

A calm comes over Luke, and he makes a decision. In the next instant he steps off the gantry platform into space. The Dark Lord looks over the platform and sees Luke falling far below. The wind begins to blow at Vader's cape and the torrent finally forces him back, away from the edge. The wind soon fades and the wounded Jedi begins to drop fast, unable to grab onto anything to break his fall.

INTERIOR: REACTOR SHAFT

Suddenly, Luke is sucked into an exhaust pipe in the side of the shaft. When Vader sees this, he turns and hurries off the platform.

INTERIOR: EXHAUST PIPE

Luke tumbles through the exhaust pipe.

He slides to the end of the slickly polished pipe and stops as his feet hit a circular grill and knock it open. Luke claws at the surface of the pipe, trying to keep from sliding out into space.

EXTERIOR: BOTTOM OF CLOUD CITY—WEATHER VANE—DUSK

Unable to hang onto the pipe, Luke tumbles out, emerging at the undermost part of Cloud City. Reaching out desperately, he manages to grab onto an electronic weather vane.

LUKE: Ben . . . Ben, please!

Luke tries to pull himself up on the weather vane but slips back down. He hooks one of his legs around the fragile instrument. All the while, a powerful current of air rushes out at him from the exhaust pipe.

LUKE: Ben. Leia!

There is an ominous cracking sound from the base of the weather vane and a piece breaks off, falling into the clouds far below.

LUKE: Hear me! Leia!

INTERIOR: MILLENNIUM FALCON—COCKPIT

Leia seems to be lost in a fog, her expression troubled. Chewie is busy operating the ship. Lando stands next to the Wookiee, watching a readout on the control panel.

LEIA: Luke . . . We've got to go back.

Chewie growls in surprise.

LANDO: What?

LEIA: I know where Luke is.

LANDO: But what about those fighters?

Chewie barks in agreement with Lando.

LEIA: Chewie, just do it.

LANDO: But what about Vader?

Chewie turns on Lando, the newcomer, with an ominous growl.

LANDO: All right, all right, all right.

EXTERIOR: CLOUD CITY—MILLENNIUM FALCON—DUSK

The Falcon makes a graceful banking turn back toward Cloud City.

EXTERIOR: CLOUD CITY—LANDING PLATFORM

Vader enters the landing platform and watches as the speck that is the Falcon disappears. The wind blows at his cape.

He turns to two aides who are standing near the entrance to the landing platform.

VADER: Bring my shuttle.

EXTERIOR: BOTTOM OF CLOUD CITY—WEATHER VANE

Nearly unconscious, Luke hangs upside-down on the weather vane as his body shifts in the wind.

EXTERIOR: MILLENNIUM FALCON—BOTTOM OF CLOUD CITY

The Falcon *dives to the underside of the floating city. Three TIE fighters close in on the starship.*

INTERIOR: MILLENNIUM FALCON—COCKPIT

Leia tries to remain calm.

LANDO: *(pointing out the cockpit window)* Look, someone's up there.

LEIA: It's Luke. Chewie, slow down. Slow down and we'll get under him. Lando, open the top hatch.

Lando rushes out of the cockpit.

EXTERIOR: BOTTOM OF CLOUD CITY—WEATHER VANE

Luke hangs by one arm from the crossbar of the weather vane. He slips from the bar and grabs onto the pole of the vane as the Falcon *banks toward him. The* Falcon *positions itself under Luke as Lando moves up through the opening of the hatch. Luke begins to slide and finally falls from the vane into space.*

INTERIOR: MILLENNIUM FALCON—COCKPIT

Out the cockpit window, Leia sees Luke falling from the bottom of the city. The ship gains on him.

LEIA: Okay. Easy, Chewie.

The Falcon *closes in on Luke.*

EXTERIOR: BOTTOM OF CLOUD CITY

Three TIE fighters race toward the Falcon, *firing away.*

INTERIOR: MILLENNIUM FALCON—HATCH

The hatch pops open with a hiss of pressure. Lando reaches out to help the battered warrior inside the ship.

INTERxIOR: MILLENNIUM FALCON—COCKPIT

Flak bursts all around it as the Falcon *banks away from the city. Leia and Chewie struggle with the controls.*

LEIA: *(into intercom)* Lando?

LANDO: *(over intercom)* Okay, let's go.

EXTERIOR: BOTTOM OF CLOUD CITY

The Falcon *races away. It is closely followed by the three TIE fighters, all of which keep up a heavy laser assault on the fleeing starship.*

INTERIOR: MILLENNIUM FALCON—COCKPIT

Explosions erupt all around the cockpit, buffeting the ship wildly. Chewie howls as he frantically tries to control the ship.

Leia and Chewie turn to see Luke, bloody and battered, enter the cockpit supported by Lando. Leia jumps up and hugs him while Chewie barks in joyous relief.

LUKE: Oh, Leia.

LANDO: All right, Chewie. Let's go.

Leia helps Luke from the cockpit as another huge blast rocks the ship.

EXTERIOR: SPACE—CLOUD CITY—DAY

The Falcon, *still followed by the three TIE fighters, races away from the cloud-covered city.*

INTERIOR: MILLENNIUM FALCON—SLEEPING QUARTERS

Luke rests on a cot, his injured arm wrapped in a protective cuff. Leia gently wipes his face. The ship lurches again.

LEIA: I'll be back.

She kisses him, then leaves the quarters.

INTERIOR: MILLENNIUM FALCON—COCKPIT

All over the ship muted alarm buzzers sound. Lando anxiously watches the flashing lights on the control panel and hurriedly adjusts some switches. Seated next to him, Chewie points out a new blip appearing on the panel. Leia, watching over their shoulders, recognizes the shape.

LEIA: Star Destroyer.

LANDO: All right, Chewie. Ready for light-speed.

LEIA: *If* your people fixed the hyperdrive.

Another explosion rocks the ship. Leia notices as a green light on the panel next to her flashes on.

LEIA: All the coordinates are set. It's now or never.

Chewie barks in agreement.

LANDO: Punch it!

The Wookiee shrugs and pulls back on the light-speed throttle. The sound of the ion engine changes . . . it is winding up. Faces are tense, expectant. But nothing happens, and the engine goes off. Chewie lets out a frustrated howl. The flak still violently rocks the ship.

LANDO: They told me they fixed it. I trusted them to fix it. It's not my fault!

Chewie gets up from his chair and starts out of the cockpit. He gives Lando an angry shove as he storms past him.

EXTERIOR: SPACE

In the distance the TIE fighters continue their chase, still shooting lasers. Vader's Star Destroyer moves behind them, determinedly following the Falcon.

INTERIOR: VADER'S STAR DESTROYER—BRIDGE

Vader stands on the bridge looking out the window as Admiral Piett approaches him.

PIETT: They'll be in range of our tractor beam in moments, Lord.

VADER: Did your men deactivate the hyperdrive on the *Millennium Falcon*?

PIETT: Yes, my lord.

VADER: Good. Prepare the boarding party and set your weapons for stun.

PIETT: Yes, my lord.

INTERIOR: MILLENNIUM FALCON—HOLD

Beeping while he works, Artoo is busy connecting some wires to Threepio who now has one leg attached.
 Chewie enters through the doorway, grunting to himself.

THREEPIO: Noisy brute. Why don't we just go into light-speed?

Artoo beeps in response.

THREEPIO: We can't? How would you know the hyperdrive is deactivated?

Artoo whistles knowingly.

THREEPIO: The city's central computer told you? Artoo-Detoo, you know better than to trust a strange computer. Ouch! Pay attention to what you're doing!

Chewie is in the pit. He is trying to loosen something with an enormous wrench. Frustrated, he uses the wrench like a club and hits the panel . . .

INTERIOR: MILLENNIUM FALCON—COCKPIT

Leia and Lando, seated in front of the control panel, are suddenly sprayed by a shower of sparks.

INTERIOR: VADER'S STAR DESTROYER—BRIDGE

Vader stands on the bridge, watching as the Millennium Falcon *is chased by the TIE fighters. As his Destroyer draws nearer, Vader's breathing gets slightly faster.*

VADER: Luke.

INTERIOR: MILLENNIUM FALCON—SLEEPING QUARTERS

Luke realizes that Vader's ship is very near. He feels resigned to his fate. He senses that he is beaten, more emotionally than physically.

LUKE: Father.

INTERIOR: VADER'S STAR DESTROYER—BRIDGE

VADER: Son, come with me.

INTERIOR: MILLENNIUM FALCON—SLEEPING QUARTERS

LUKE: *(moaning)* Ben, why didn't you tell me?

INTERIOR: MILLENNIUM FALCON—COCKPIT

Lando and Leia are at the controls of the Falcon. *Meanwhile, in the ship's hold, Chewie continues to work frantically on the hyperdrive mechanism.*

LANDO: *(into intercom)* Chewie!

EXTERIOR: SPACE

The Falcon *races through space followed very closely by the TIE fighters and the huge Imperial Star Destroyer.*

INTERIOR: MILLENNIUM FALCON—COCKPIT

Luke enters the cockpit and looks out the window. He is almost unconscious with pain and depression.

LUKE: It's Vader.

INTERIOR: VADER'S STAR DESTROYER—BRIDGE

VADER: Luke . . . it is your destiny.

INTERIOR: MILLENNIUM FALCON—COCKPIT

LUKE: Ben, why didn't you tell me?

INTERIOR: VADER'S STAR DESTROYER—BRIDGE

PIETT: Alert all commands. Ready for the tractor beam.

INTERIOR: MILLENNIUM FALCON—HOLD

Artoo races to a control panel and starts working on a circuit board. Furious, Threepio stands on one leg, yelling.

THREEPIO: Artoo, come back at once! You haven't finished with me yet! You don't know how to fix the hyperdrive. Chewbacca can do it. I'm standing here in pieces, and you're having delusions of grandeur!

Artoo moves a circuit on a control panel. Suddenly, the control panel lights up.

INTERIOR: MILLENNIUM FALCON—COCKPIT

Leia and Lando are thrown back into their seats as the Millennium Falcon *unexpectedly shoots into hyperdrive.*

INTERIOR: MILLENNIUM FALCON—HOLD

The ship tilts up and Artoo topples into the pit on top of Chewie.

THREEPIO: Oh, you did it!

EXTERIOR: SPACE

The Falcon *soars into infinity and away from the huge Star Destroyer, which seems, by contrast, to stand still.*

INTERIOR: VADER'S STAR DESTROYER—BRIDGE

Admiral Piett and another captain glance at Vader in terror. Vader turns slowly and walks off the bridge, his hands held behind his back in a contemplative gesture.

EXTERIOR: SPACE—REBEL STAR CRUISER

The Millennium Falcon *is attached to a huge Rebel cruiser by a docking tube. Rebel fighters move about the giant cruiser, and a Rebel transport ship hovers near the fleet.*

INTERIOR: MILLENNIUM FALCON—COCKPIT

Lando sits in the pilot's seat as he talks into the comlink. Chewie busily throws a variety of switches in preparation for takeoff.

LANDO: *(into comlink)* Luke, we're ready for takeoff.

LUKE: *(over comlink)* Good luck, Lando.

LANDO: *(into comlink)* When we find Jabba the Hutt and that bounty hunter, we'll contact you.

INTERIOR: STAR CRUISER—MEDICAL CENTER

Luke speaks into the comlink as a medical droid works on his hand. Leia stands near him while Threepio and Artoo look out the window.

LUKE: *(into comlink)* I'll meet you at the rendezvous point on Tatooine.

INTERIOR: MILLENNIUM FALCON—COCKPIT

LANDO: *(into comlink)* Princess, we'll find Han. I promise.

INTERIOR: STAR CRUISER—MEDICAL CENTER

LUKE: *(into comlink)* Chewie, I'll be waiting for your signal.

Chewie's wail comes over the comlink.

LUKE: *(into comlink)* Take care, you two. May the Force be with you.

Luke looks down at his hand. A metalized type of bandage has been wrapped around his wrist. The medical droid makes some adjustments in a tiny electronic unit, then pricks each one of Luke's fingers.

LUKE: Ow!

Luke wriggles his fingers, makes a fist, and relaxes it. His hand is completely functional.

He gets up and walks over to Leia. There is a new bond between them, a new understanding. Leia is thinking about Han, Luke is thinking about his uncertain and newly complicated future. Together they stand at the large window of the medical center looking out on the Rebel Star Cruiser and a dense, luminous galaxy swirling in space. Luke puts his arm around Leia. The droids stand next to them, and Threepio moves closer to Artoo, putting his arm on him. The group watches as the Millennium Falcon *moves into view, makes a turn, and zooms away into space.*

EXTERIOR: SPACE—REBEL STAR CRUISER

While Luke, Leia, and the droids stand, looking out the window of the star cruiser, two escort fighters join the large ship. Slowly, the cruiser turns and moves away into space.

DISSOLVE TO:
EXTERIOR: GALAXY–SPACE
END CREDITS FADE IN AND OUT OVER BACKGROUND
THE END